M A S T E R P I E C E S O F

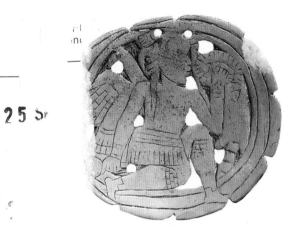

AMERICAN
INDIAN ART

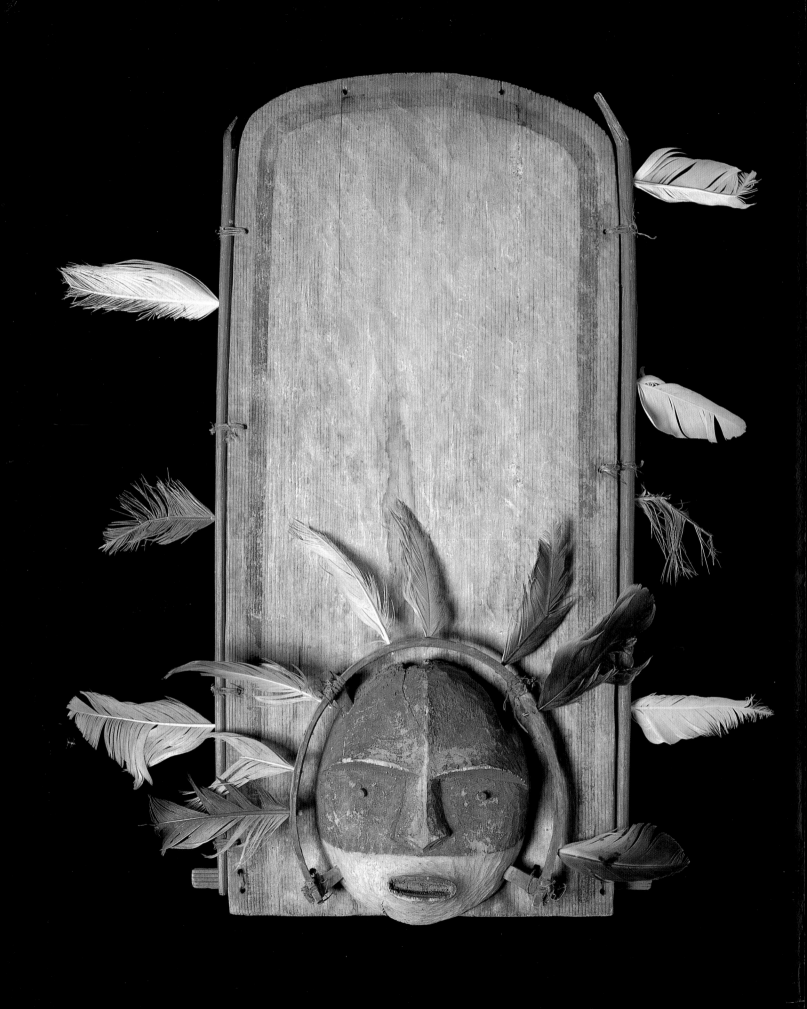

MASTERPIECES OF

AMERICAN INDIAN ART

FROM THE EUGENE AND CLARE THAW COLLECTION

TEXT BY

GILBERT T. VINCENT

PHOTOGRAPHS BY

JOHN BIGELOW TAYLOR

HARRY N. ABRAMS, INC., PUBLISHERS
IN ASSOCIATION WITH THE NEW YORK STATE HISTORICAL ASSOCIATION

EDITOR'S NOTE: in the data section of each caption is a T number. This is the museum's acquisition number. For precise reference to any object this number should be used.

In dimensions, when not otherwise indicated, height precedes width and depth.

Page 1: For caption see page 12.
Page 2: For caption see page 94.

Editor: Robert Morton
Designer: Dana Sloan

Library of Congress Cataloging-in-Publication Data

Vincent, Gilbert Tapley, 1946–
Masterpieces of American Indian art : from the Eugene
 and Clare Thaw Collection / text by Gilbert T. Vincent;
 photographs by John Bigelow Taylor.
 p. cm.
 Includes bibliographical references (p.).
 ISBN 0–8109–2628–8
 1. Indians of North America—Art—Catalogs.
 2. Fenimore House Museum (Cooperstown, N.Y.)—Catalogs.
 3. Thaw, Eugene Victor—Art collections—Catalogs.
 4. Thaw, Clare—Art collections—Catalogs.
I. Taylor, John Bigelow. II.Title.
E98.A7V56 1995
704' .0397073'07474774—dc20 95–2110

Printed and bound in Japan

CONTENTS

PREFACE

Over the centuries objects from American Indian culture have been collected, preserved, viewed, and interpreted from many different perspectives. In public museums of the last hundred years archeologists, art historians, anthropologists, and historians have promoted specific viewpoints derived from their particular disciplines. Recently various American Indian groups have been active in promoting their interpretations, most dramatically through the exhibitions and catalogues of the National Museum of the American Indian.

All points of view add to an appreciation of the rich complexity of history, to an understanding of different peoples through cultural exchange, and to a greater awareness of the American Indian heritage. One method of interpretation is not necessarily superior to another, and new ideas will continue to add to a better, broader, and possibly more applicable perspective for changing generations in the years to come. A motivating force behind the creation of the Eugene and Clare Thaw Collection of American Indian Art is a deep appreciation and knowledge of the arts of Western civilization, and this knowledge has now been brought to focus on the arts of the American Indian.

In 1991 the Thaws approached the New York State Historical Association concerning the possible donation of their American Indian objects. Since that time plans have progressed rapidly. The Association's trustees, led by chairman Gates Helms Hawn, enthusiastically endorsed the proposal of new galleries. With the assistance of his able staff Hugh Hardy of Hardy, Holzman, Pfeiffer created architectural drawings for a new wing to be added to the Association's Fenimore House Museum. A public groundbreaking ceremony, held in July 1993 at the Association's ninetieth annual meeting for trustees and members, was led by Chief Jake Swamp, founder of the Tree of Peace Society. Chief Leon Shenandoah, Tadodaho, Speaker of the Chiefs of the Iroquois Confederacy, opened the proceedings with a Thanksgiving Address. Chief Bernard Parker, Joanne Shenandoah, Hugh Hardy, and W. Richard West, Jr. Director of the National Museum of the American Indian, were among the speakers. In his presentation from the Iroquois Nations, Chief Parker stated that: "The time is upon us to respect each other's cultures and share a path to the future together." This has been the moving spirit behind our endeavors.

This publication celebrates the opening of the wing in 1995, and illustrates a representative selection of one hundred objects. The text is derived from a catalogue of the entire collection. The authors are Ted J. Brasser for the Woodlands and Plains entries, Steven C. Brown for the Northwest entries, Andrew H. Whiteford for the Southwest and California entries, and Ralph T. Coe, who also served as general editor, for the Alaskan entries. I thank them for their extensive knowledge and erudition. Thanks also are due to many other knowledgeable scholars and experts in the American Indian field who have shared their thoughts and expertise on individual objects. I want particularly to thank Jonathan Holstein, who has provided sound advice throughout the project, and also Jonathan Batkin, Bruce Bernstein, Sherry Brydon, Kate C. Duncan, Barbara A. Hail, George R. Hamell, Charles F. Hayes III, Edmund Ladd, Mary Jane Lenz, Joan A. Lester, Jeffrey R. Myers, David W. Penney, Ruth B. Phillips, John Ware, and Barton Wright. The superb photographs are the work of John Bigelow Taylor.

Many people have been instrumental in both the production of this volume and the construction of the wing. Jane Forbes Clark has been an indispensable leader in so effectively carrying on the extraordinary tradition of her grandfather, Stephen C. Clark, in the arts and education. The unfailing support of Edward W. Stack and the Clark Foundation has been crucial from the beginning. The staff members of the New York State Historical Association, particularly Anna S. M. Symington, have been unstinting of time and effort. Andrew R. Mancini Associates has built a superb structure, and Project Manager Edward Gaynor has been directly responsible for the successful completion of the building on a tight schedule. Stephen Saitas has designed exhibit cases of remarkable beauty, effectiveness, and originality; APV Associates has designed lighting with sensitivity toward aesthetics and conservation concerns. Guidance by conservators Paul Himmelstein and Barbara Appelbaum has been extremely helpful from the beginning of the project. The services of Philippa Polskin and Andrea Lowen of Arts and Communications Counselors has been essential. Lastly, none of this would have been possible without the foresight and generosity of Eugene and Clare Thaw.

Gilbert T. Vincent

INTRODUCTION

Recent archeological evidence suggests that human arrival on the North American continent dates to about 50,000 B.C. or earlier and took place over thousands of years as routes opened across a land bridge in the area of the Bering Sea. During the subsequent millennia, very different cultures evolved in response to the various living conditions as the people utilized local resources and adapted to the natural environment. These conditions varied widely from the frozen Arctic tundra to deserts in the Southwest, from vast wooded stretches in the Northeast to treeless plains in the West, from Floridian swamps to mountainous areas in the Rocky Mountains.

In what is now the United States and Canada, hundreds of distinct cultures evolved, each with a wide variety of language, sociopolitical organization, and religious beliefs. These cultures created many different kinds of artifacts for many different purposes—utilitarian, religious, healing, and other.

Pottery was made in the Southeast as early as 2500 B.C. About 2,000 years later, the rich clay deposits of the Southwest instigated the complex pottery traditions that are still so vibrant today. The natives of the San Joaquin and Sacramento River valleys in California developed an extraordinary basket-making tradition. Nomads of the Plains utilized the buffalo skin for clothing, containers of all types, even housing, and decorated these objects with symbols and designs worked in incised lines, porcupine quill embroidery, or paint. The characteristics of birch bark allowed a decorative engraving tradition to develop in the Northeast.

Exact tribal areas were ill-defined and changed over time. Large mass movements of people took place. The Apache and Navajo are Athapaskan speakers and migrated about 1,000 years ago from the area of Northwestern Canada. More recently, the Algonquian-speaking Cheyenne moved east from the Mississippi to the Great Plains. Native trade routes also brought cultural change, but certainly by the time of European arrival the aboriginal peoples had evolved a stable adaptation to their local environments and the natural resources available.

Each tribe produced artifacts as a part of daily life. Whether for strictly functional reasons or for ceremonial purposes the two were often intertwined. Symbolic imagery was often included to enhance an object's power. This can be seen, for example, in the elk antler club on page 74, a war implement that includes decorative and most likely spiritual imagery on the shaft. Specific types of objects made by one tribe were sometimes traded to others and were greatly valued because of their rarity. The Utes, for instance, so prized the Navajo Chief blanket design generally identified as first phase that the form is also known as a Ute blanket (see page 58).

Beginning in the late fifteenth century, a growing stream of explorers, traders, and fishermen brought a great change to the native world. In respect to the standards of American Indian art new tools, materials, and design sources, brought changes in artistic production. Metal axes and chisels facilitated larger scale and more intricately carved totem poles on the Northwest Coast. Iroquois combs developed a delicacy and refinement that was not possible before metal saws (see page 20). European products, such as glass beads and metal needles, offered new decorative devices that superseded the traditional quillwork embroidery in many areas. In the seventeenth century instruction at the Roman Catholic missions in French Canada are thought to have introduced to Indian needleworkers the curvilinear floral patterns of French Renaissance design, a style that spread throughout the tribes of the Great Lakes region (see page 24).

Europeans collected American Indian material beginning with their first contact. Explorers brought back a variety of objects, although their primary interest was in more marketable substances such as gold or spices. Columbus transported various examples of Indian craftsmanship and New World flora and fauna as well as six Indians on his first return voyage. Other explorers brought back American Indian objects that appealed to some Europeans because of their strangeness and exotic imagery. A few thought them ingenious. The famous German artist, Albrecht Dürer, saw some of the Aztec gold and featherwork sent by Cortes to Charles V and wrote in his diary in 1520 that he marveled at the "wonderful works of art." On the whole, however, these things made little impact on the aesthetic taste of Europe at that time. A few European monarchs, wealthy private citizens and fledgling naturalists or anthropologists set up small rooms or cabinets of curiosity, called *Wunderkammern*, in Germany (literally "wonder rooms"), that appealed to scientific or humanistic interests. These collections were privately owned, but open to those with appropriate credentials.

In America in the 1780s Charles Willson Peale, an artist and amateur naturalist, opened a museum at his home in Philadelphia that exhibited his portraits of famous contemporaries and a growing natural history collection that included a few Indian artifacts. Beginning in 1790, historical and cultural organizations in the young United States were given a growing assortment of Indian objects. The Society of St. Tammany, originally a cultural organization, exhibited a collection of Indian relics in New York City and the following year the Massachusetts Historical Society received the gift of several Northwest Coast objects from the voyage of the *Columbia*, the first American trading vessel to reach the Oregon territory.

At about this time the concept of a public museum took root with the French Revolution, when the vast art collections of the French crown were placed in the palace of the Louvre and opened to the public in 1793. The concept of a museum owned by and open to the general populace spread throughout Europe. In the United States several university and college museums were organized for teaching purposes in the early nineteenth century, and the first great public art museums were founded in the 1870s in New York City, Boston and Philadelphia. These museums, however, were almost exclusively reserved for objects of European classical antiquity, and for painting and sculpture from the Renaissance to modern times. American Indian objects remained within the context of the historical settlement of North America or became part of ethnographic collections in natural history museums.

Not surprisingly the first Americans to view Indian objects within the context of art were artists, even though Dürer had expressed wonder as early as the sixteenth century. In the 1830s the American painter George Catlin acquired a large collection of Plains artifacts, as did several subsequent artists such as Frederic S. Remington and Charles M. Russell. But their interest was essentially tied to their needs as genre painters. Artifacts were used as props for paintings, and their appeal for the painters was related to a quest for authentic depiction, not aesthetic appreciation.

The first artists to notice American Indian objects as art and to be inspired by native aesthetics were early-twentieth-century modernists. Pablo Picasso's interest in Spanish primitive art and African sculpture is well known, and his attention toward the artistic expression of these non-European art forms was echoed by his fellow artists in the school of Paris. American Indian material appealed to the Surrealists, notably Paul Eluard, Max Ernst and André Breton, who had formed collections by the 1920s. In the United States the Denver Art Museum began displaying American Indian objects as art rather than ethnographic material in 1925 under the curatorial leadership of Frederic H. Douglas. The first American art exhibition to consciously present Indian objects was arranged by the artist John Sloan, a member of the Ashcan School and an early American modernist and the anthropologist Oliver LaFarge. In 1919 Sloan had commenced yearly pilgrimages to Santa Fe, where he became interested in Indian art and culture. The exhibition that Sloan and LaFarge organized in 1931 traveled across the United States and was accompanied by a catalogue which proclaimed that it was "the first exhibition of American Indian Art

selected entirely with consideration of esthetic value." The Brooklyn Museum reorganized its American Indian collection along aesthetic lines in the early 1930s, and a precedent-setting exhibition, *Indian Art of the United States,* was organized by Rene d'Harnoncourt and Frederic H. Douglas in 1941 at the Museum of Modern Art in New York City.

THE COLLECTION revealed to the public for the first time in this book and at Fenimore House Museum in Cooperstown, New York, was formed by Eugene and Clare Thaw. In 1950 Eugene Thaw became a dealer in fine arts of the European tradition, particularly Old Master drawings and paintings. By avocation he and his wife, Clare Eddy Thaw, are collectors. Their collection of American Indian art began in 1987 in a gallery in Santa Fe, New Mexico. Clare Thaw was attracted to the Victorian floral designs of what was described as a table cloth. The beadwork included representations of the American flag and when the Thaws discovered an illustration of the object in Richard Pohrt's 1976 catalogue, *The American Indian, The American Flag* the search for Indian art with a flag motif was begun.

The Thaws did not acquire every available object that included a flag, but made a selection of those that appealed to their taste. Several other items from the Pohrt exhibition were acquired, and another group from the collection of James Waste. Objects of rarity and unusual design, such as a fully beaded violin case made for George Schmidt and dated December 25, 1899, were a particular focus. For approximately two years, the Thaws restricted their interest to flag-related American Indian material. This attention resulted in a collection of fifty-four objects that was included in the 1993 catalogue *The Flag in American Indian Art* by Toby Herbst and Joel Kopp, which was published by the New York State Historical Association.

The experience of collecting the flag material proved to be an unintentional introduction to the larger goal of acquiring a representational American Indian collection. Seeking out the flag material had educated their eyes and whetted their interest for all American Indian art. It had renewed their friendship with Ralph T. Coe, a leading scholar and collector of American Indian art, who offered knowledgeable and experienced advice, and who had also led a successful career in the field of European fine arts, culminating as the director of the Nelson-Atkins Museum in Kansas City.

Building the flag collection had also introduced the Thaws to the major dealers and their galleries. They visited museum collections in the United States, Canada and Europe for a wider view of American Indian material. Eugene Thaw acquired as complete a library as possible including magazine publications and auction catalogues. He studied and became familiar with the major types of objects in such important texts as *The Eagle, the Jaguar and the Serpent,* by Miguel Covarrubias, Ted Brasser's *The Spirit Sings* and Richard Conn's *Native American Art.* When some of these objects came on the market the Thaws sought to acquire them.

From their earliest purchases, the Thaws focused on collecting American Indian material as art, not as cultural, ethnographic, craft, or decorative objects. Their interest was in aesthetic quality. After a few individual acquisitions such as a Tesuque jar, a Yokut basket, and a San Ildefonso jar, Thaw purchased from Stefan Edlis fifteen Northwest Coast items including a Tsimshian feast ladle, raven rattle and frontlet, and a Tlingit clan hat. This group contained material of such extraordinary quality that it gave a new standard for future collecting. Other individual purchases both added to the Northwest Coast material and expanded into other cultural areas. In 1990 the Thaws purchased seventeen Woodlands objects in pristine condition that are thought to have been collected by the Countess of Elgin in the early nineteenth century. The next year seven outstanding objects including a pair of finger masks and two larger masks were acquired from Andre Nasser for the collection.

By 1991, the Indian material numbered over two hundred and fifty objects and it had outgrown the walls, tables, and shelves of their home. They then made the decision to give their collection to the American public. The Thaws began looking at various institutions across the United States and eventually selected the Fenimore House Museum of the New York State Historical Association in Cooperstown, New York. In the end the selection was a natural one; the Fenimore House Museum was in an area that they knew well, being near their farm. But the site seemed appropriate because it had also been the home of James Fenimore Cooper and the setting for several of his famous novels, which of course dealt with American Indian characters. Equally important was that the museum also housed a distinguished collection of American folk art, Hudson River School paintings, historical portraits, and decorative arts. These seemed to fit well with the Thaws' vision of American Indian art. A neighboring Farmers' Museum also seemed a natural site for craft demonstrations related to the new collection. Finally, it was the existence of extensive educational programs, including a graduate program in museum studies, that tipped the balance in favor of the New York State Historical Association.

The staff and trustees of the museum responded enthusiastically to the offer. The Thaws were drawn in to the plans not only for galleries, but also for forthcoming exhibitions, educational programs that included training museum specialists in American Indian art, and a long-term goal of a research center. Responding to these possibilities for the future they undertook on their own initiative to broaden the collection to make it as representative as possible. They continued to buy individual items, securing rare examples of prehistoric pottery, completing a chronological sequence of nineteenth-century bandolier bags, and adding an important example of Northeastern birchbark engraving on a model canoe by Tomah Joseph. A large gap was filled by purchasing a collection of Southwestern textiles from Gerald Peters, ten examples of Southwestern pottery from the Gallegos Collection, and a large group of Northwest Coast pieces from the Taylor Museum of Colorado Springs.

Eugene and Clare Thaw assembled their American Indian collection from the inspiration of strong personal interests in art. Their choice of objects was dictated first and foremost by an experienced connoisseurship. They made careful selections in which each possible purchase had to compare well with other known examples of a similar object. Each item had to appeal to them in relation to design, craftsmanship, and color. Surface patina, specifically a mellowed sense of use and age, was an overriding concern. Secondly, they respected the ethical standards of the time and avoided any sensitive material, such as undocumented excavated material or anything directly associated with human remains. The condition of each object was an important consideration, as was the exhibition and ownership history. As the collection and their knowledge grew, they expanded their concept of acquiring individual works of art to creating a representative group of objects.

The result of the Thaws' collecting is an extraordinary assemblage of rare and important examples of American Indian art. Objects date from 500 B.C. to the present day, and give an effective and comprehensive overview of the highest artistic levels of American Indian culture throughout North America. The new wing of the Fenimore House Museum includes the Eugene and Clare Thaw Gallery, a permanent display of two hundred objects arranged geographically. A large temporary exhibition gallery concentrates on fabrication techniques, design styles, and the identification of different cultural traditions. The central hall exhibits some of the larger objects, and a small auxiliary gallery is dedicated to the ledger drawing collection. An open storage gallery allows the remainder of the collection to be visible to the public. A 120-seat auditorium will be used for extensive education programs, which are an important component of the Association's goals. The existing graduate program in museum studies will be directly involved with the collection, and internships are proposed for anyone interested in American Indian art. It is very fitting to note that the Thaw Collection, conceived in such a generous spirit of sharing, is located on the shore of Lake Otsego, an Iroquois word comprised of "ot," a prefix meaning water, and "sego," a kind of greeting: in other words, a place to come together by the water.

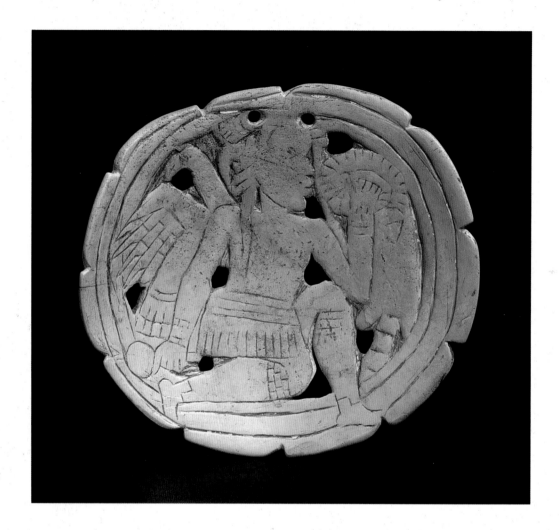

SOUTHEASTERN WOODLANDS

SHELL GORGET

Spiro area, Oklahoma, probably Caddoan. Mississippian Period, A.D. *1200–1350. Busycon conch shell. 4¼" diam. T1. Found at the Lehew Site near Chickasha, Grady County, Oklahoma, by Mrs. Wayne Lehew, 1981; George Terasaki Collection, New York*

Gorgets were suspended from the wearer's neck as throat armor or ornamentation. The image depicts a kilted human figure holding a rattle and a raccoon pelt. It may represent a ritual transformation of a bird-man or raccoon-man.

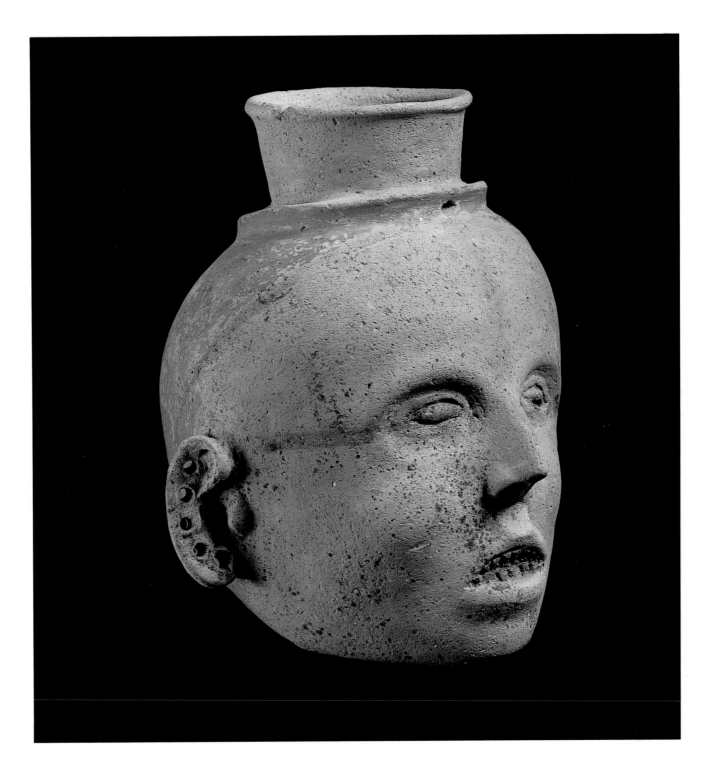

CERAMIC HUMAN-HEAD EFFIGY JAR

Parkin Site, Cross County, Arkansas. Late Mississippian Period, A.D. 1300–1500. Buff-colored ceramic. 7¾" h. T3. Private Collection, Cross County, Arkansas; Jon C. Griffin Collection, Columbia, South Carolina

Jars in the shapes of human heads have been found in several Late Mississippian sites. The decorative face painting or tattoos suggest a member of the elite, although it is unknown if the jars represent individual community leaders or the severed head of an enemy.

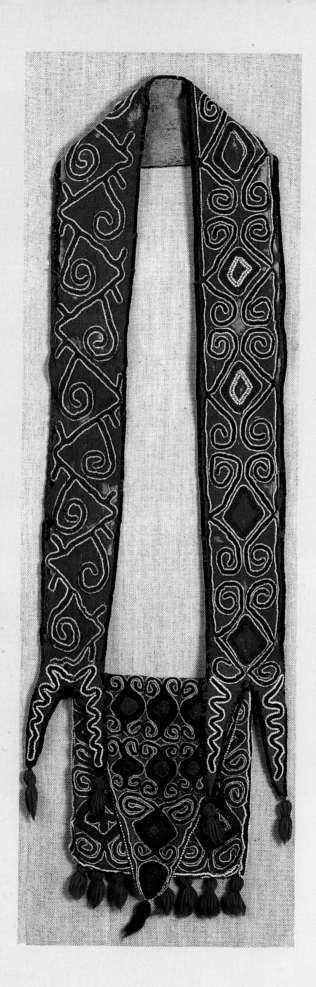

BANDOLIER BAG

Seminole type. Florida. c. 1830.
Trade cloth, yarn, glass beads,
cotton backing. 28½ l. × 8½" w.
T5. Descended in the Henry
Stevens family, Barnet, Vermont;
Christopher Selser, Santa Fe;
Morning Star Gallery, Santa Fe

The form of bandolier bags
may have been borrowed from
European shoulder pouches or
haversacks. They became pop-
ular in the nineteenth century
as decorative accouterments at
ceremonies and dances. The
stylized embroidery patterns
and pointed flap are distinctive
features of Seminole work.

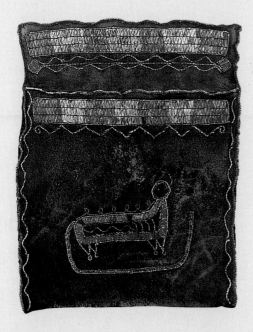

FLAT POUCH

Ottawa or cultural relatives. Eastern Great Lakes. c. 1780. Black-dyed deerskin, porcupine quills. 10½ × 8". T7. Christie's, London July 4, 1989, lot 27; Ron Nasser, New York

Pouches of this type were worn on the chest by means of a neck strap. The quillwork decoration represents either thunderbirds, snakes, or horned underwater panthers, as here. It is thought that these pouches held charms related to hunting as well as pipes and tobacco, which were used in rituals to honor the game spirits.

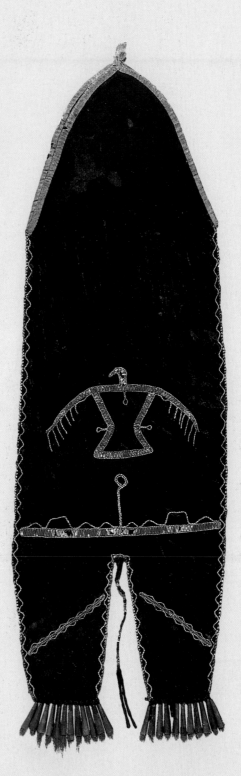

TABBED SKIN BAG

Ottawa or cultural relatives. Eastern Great Lakes. c. 1790. Black-dyed deerskin, porcupine quills, silk binding, hair tassels, tin cones. 20½" l. T8. Acquired by Colonel Return Jonathan Meigs (1740–1823) traditionally from Delaware Indians in Ohio in 1795; descended in family; Sotheby's, #6245, November 25, 1991, lot 88

The fundamental concepts of sky, earth, and underworld are represented in the quillwork design by the thunderbird, a stylized plant form on a horizontal band, and abstracted reptiles reduced to two diagonal lines. Ceremonial leaders of the Black Dance probably carried bags of this type.

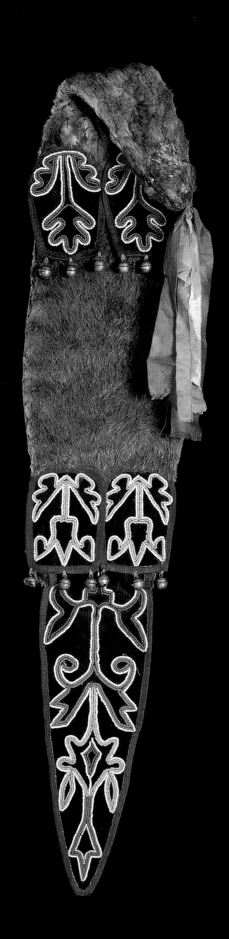

OTTERSKIN MEDICINE BAG

Winnebago. Wisconsin. c. 1860–70. Otter pelt, cotton cloth, ribbons, glass beads, brass bells, blue clay pigment. 29 l. × 5¾″ w. T11. Descended in Winnebago family in Wisconsin Dells, Wisconsin; David Wooley, Corrales, New Mexico, in 1978; Toby Herbst, Santa Fe

Each member of the Medewiwin, the Grand Medicine Society of the Great Lakes area, owned a ceremonial bag such as this to hold sacred paraphernalia needed at meetings. The striking abstract floral forms are arranged with strict bilateral symmetry.

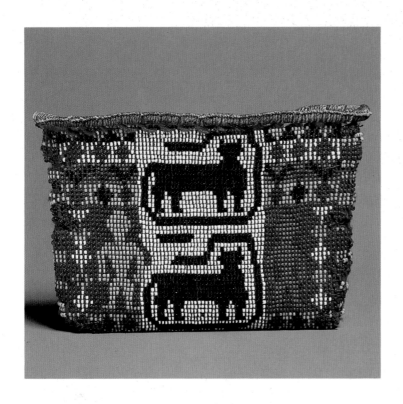

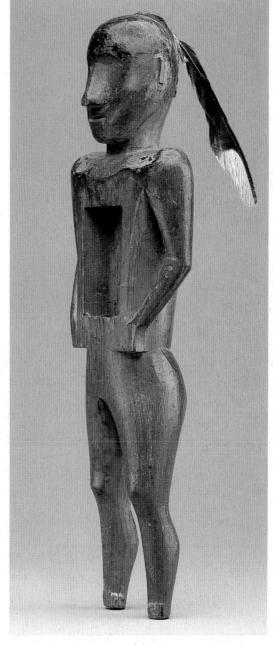

CHARM BAG

Mesquakie. Iowa.1870–80. Glass beads, wool yarn, twine. 6½ × 4⅝″. T12. Descended in a Mesquakie family, Tama, Iowa; Benson Lanford, Santa Fe; David Wooley, Corrales, New Mexico; Toby Herbst, Santa Fe

During the 1870s outstanding women artists of several western Great Lakes tribes demonstrated their creativity and technical ability in the fabrication of small exquisite charm bags which held the owner's sacred objects. Each side shows different designs, the mythical underwater panther depicted here being one of the most common.

WOODEN DOLL

Great Lakes. Nineteenth century. Wood, paint, feather. 10¾ l. × 3¾″ w. T10. George Terasaki Collection, New York

Great Lakes Indians used carved wooden figurines in ceremonies to control human behavior or health, or as protection against evil. The rectangular cavity in the stomach of this particularly sculptural figure probably held small herbal potions bound by a cloth and used in curing disease by native doctors. Among the Ojibwe and other Great Lakes people, these doctors usually belonged to the Medewiwin or Grand Medicine Society.

Sauk and Fox. Kansas/Iowa. 1840–50. Deerskin, glass beads, shell pendants. 19½ × 6⅜". T18. Alexander Gallery, New York; Morning Star Gallery, Santa Fe

The shapes of skin bags evolved into different decorative forms in the late nineteenth century, but often retained a reference to the legs, head, and tail of the original pelt. The beaded tabs at the top and bottom of this bag represent such a memory. This bag is a rare example of the mid-nineteenth century Sauk and Fox type.

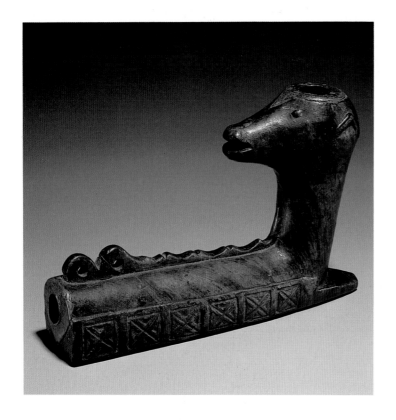

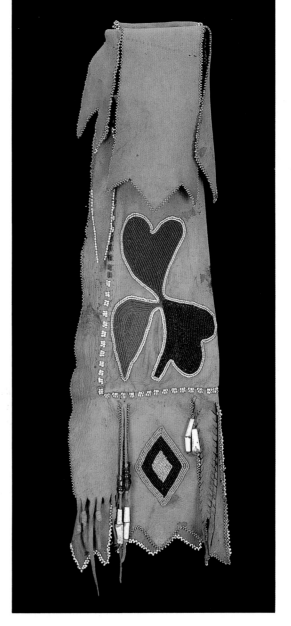

EFFIGY PIPE BOWL

Eastern Ojibwe. Michigan/Ontario. c. 1790. Maple wood, lead inlay and lining. 5½ × 3½". T13. James Economos, Santa Fe; Taylor A. Dale, Santa Fe

The design of the pipe bowl is termed self-directed because the bear effigy has been carved to face the smoker. The cross pattern along the side probably represents the four cardinal directions. On the bottom the outline of an otter pelt inlaid in lead may refer to the trade value of the pipe, a valuable object made by a talented carver.

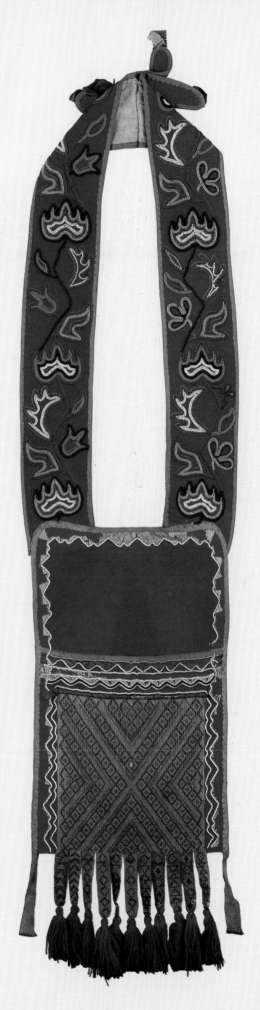

BANDOLIER BAG

Northern Minnesota or Red River Ojibwe. c. 1860. Glass beads, silk ribbon, red trade cloth, cotton lining, yarn. 44 × 9¾". T16. Skinner's, #1487, January 9, 1993, lot 345

Fully beaded bandolier bags became fashionable among the native people of Wisconsin and Minnesota around 1850. Over the following decades such bags appear with increasingly elaborate decoration. Here, the woven beadwork panel still retains the X motif derived from earlier yarn-plaited bags.

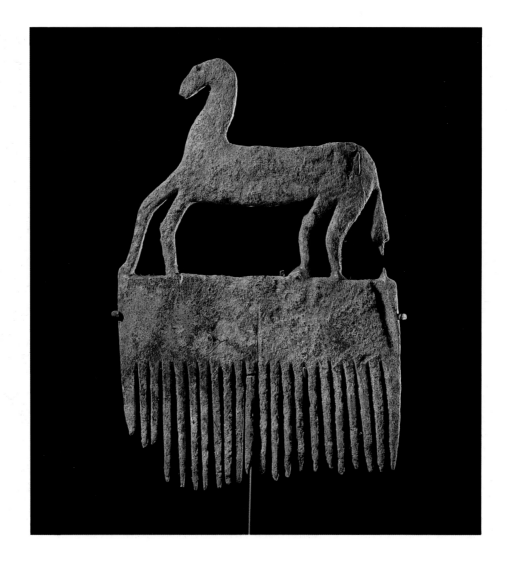

ANTLER EFFIGY COMB

*Seneca. New York. 1670–87. Moose or elk antler. 4¼ × 2⅞". T24.
Recovered from the Boughton Hill site near Victor, New York, by Harry
L. Schoff in the 1930s; Lester and Clarence Bill, Canandaigua,
New York; F. Llewelyn Casterline Collection, Belmont, New York;
Skinner's, 1990; Jonathan Holstein, Cazenovia, New York*

Since late prehistoric times, the Iroquois carved effigy-
decorated combs from bone, wood or antler. The introduction
of European metal tools brought an elaboration in technique
and comb production reached a peak between 1650 and 1700.
The image of a single horse on this comb may refer to the first
appearance of a European horse in Seneca country in 1677.

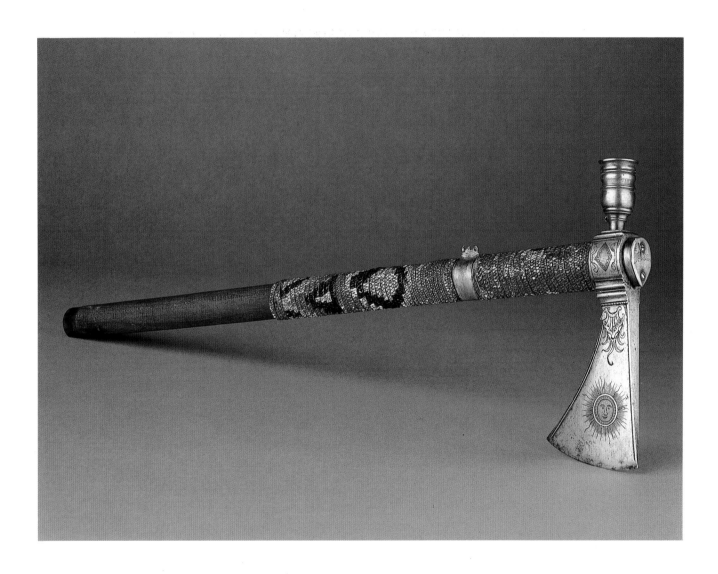

PIPE TOMAHAWK

Metalwork attributed to Richard Butler, Pennsylvania. c. 1770. Iron, steel, silver plate, pewter, quillwork, wood. Shaft 21⅛" l.; blade 7¼" l. T28. The Earls of Warwick Collection, Warwick, England; on long-term loan

Pipe tomahawks are unique to North America. They combine the functions of a pipe and a hatchet, but in this elaborate form they were used as presentation pieces at peace treaties or as gifts. The "R. Butler" engraved under the blade may identify the gunsmith Richard Butler as the maker and the "Lt. Maclellan" engraved on the end may be the original owner. A Delaware or Iroquois plaited the quillwork.

HUMAN-HEADED CLUB

Susquehannock or Southern Iroquois. Mid-Atlantic Area. 1770–1800. Wood, iron, pigments. 20¾ l.× 4¼ w. × 5¼" depth. T29. Private Collection, Virginia; Greg Quevillon, Santa Fe; Sotheby's, London, #8991, June 16, 1980, lot 35; Jonathan Holstein, Cazenovia, New York

This impressive club is related to Iroquois human-headed clubs, but has unique details in the articulation of the facial features and the inclusion of an iron-bound projection at the back of the head in the manner of a hair bun. These features and the fact that it was found in Virginia reinforces the Susquehannock/Iroquois attribution.

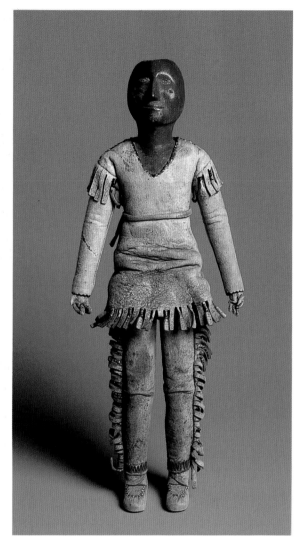

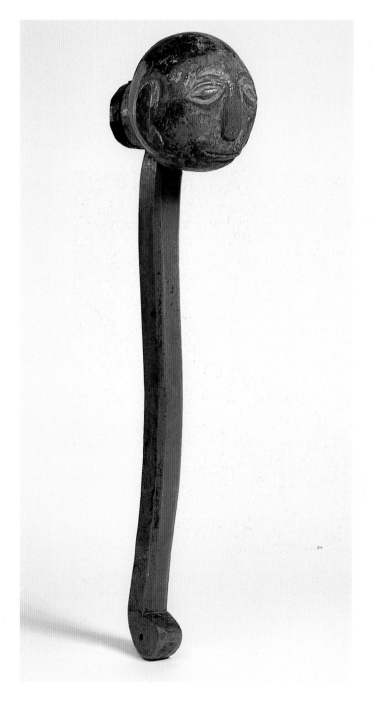

DOLL

Iroquois or Mississauga. Southern Ontario. c 1790. Wood, buckskin, porcupine quills, pigments. 10 × 4⅝". T30. According to family tradition the doll is one of two which were given to Dr. James Macaulay (1759–1809) in gratitude for treating an Indian chief about 1792; descended in Macaulay family; Christie's, London, December 3, 1991, lot 18; Taylor A. Dale, Santa Fe

The fringed buckskin shirt, leggings, and vamp moccasins duplicate typical Woodlands dress for the late eighteenth century. The red and black face painting is seen on several Iroquois masks and is thought to represent east and west or morning and afternoon. A roach and spreader once attached to the back of the doll's head is now lost.

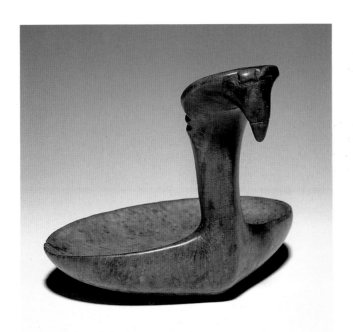

WOODEN SPOON

Onondaga. c. 1760. Ash burl. 4½ × 5¼″. T31. Onondaga Indian Reservation, New York; Trotta-Bono, Shrub Oak, New York

Among the Iroquois dreams function as a major motivation in the carving of effigies on ladles, spoons, bowls, and pipes. This image bears the abstract, almost enigmatic, qualities of eighteenth-century Iroquois art, although it resembles the stance and features of a predatory bird.

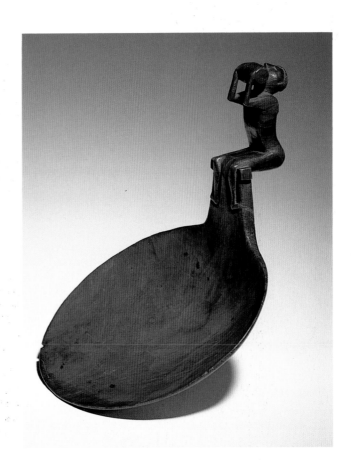

WOODEN LADLE

Wyandot. Detroit Area/Northwestern Ohio. c. 1750. Wood. 9½ × 6¾″. T32. Private Collection, Massachusetts; Sotheby's, #4943, October 23, 1982, lot 132; Andre Nasser, New York

The carving on this ladle is a magnificent example of Wyandot artistry. The effigy of a man drinking from a rum keg probably refers to the shamanistic White Panther cult in which the ceremonial use of rum caused its members to have visionary experiences.

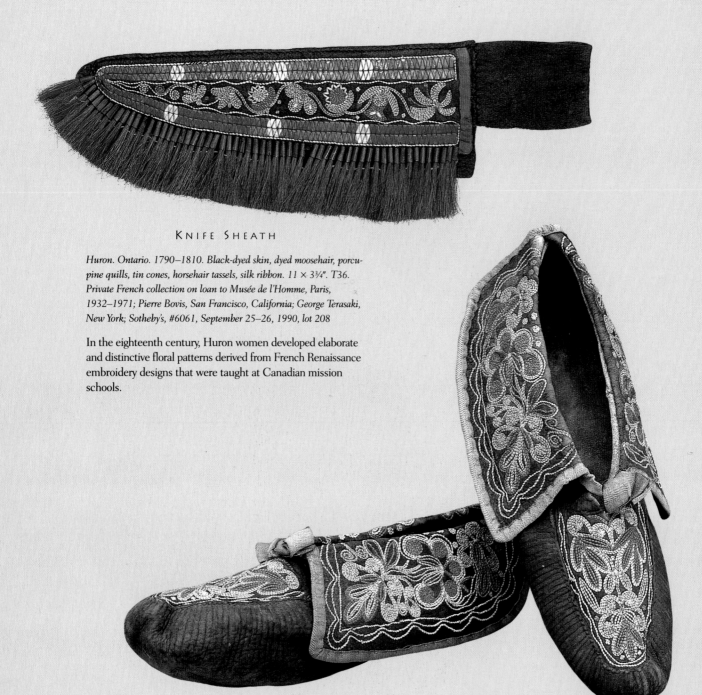

KNIFE SHEATH

Huron. Ontario. 1790–1810. Black-dyed skin, dyed moosehair, porcu-pine quills, tin cones, horsehair tassels, silk ribbon. 11 × 3¾". T36. Private French collection on loan to Musée de l'Homme, Paris, 1932–1971; Pierre Bovis, San Francisco, California; George Terasaki, New York; Sotheby's, #6061, September 25–26, 1990, lot 208

In the eighteenth century, Huron women developed elaborate and distinctive floral patterns derived from French Renaissance embroidery designs that were taught at Canadian mission schools.

MOCCASINS

Huron. Ontario. c. 1820. Black-dyed skin, dyed moosehair, cotton binding. 9½ × 3½". T37. G. Moore, England; J. T. Hooper Collection, England; Christie's, #4789, London, June 23, 1992, lot 129

Ursuline nuns in colonial Quebec taught the regional Indians the techniques and floral patterns of European embroidery. The natural talent of Indian women soon produced work of extremely high quality. The sale of such moccasins to travelers in the area became an important source of income for the Hurons in the early nineteenth century.

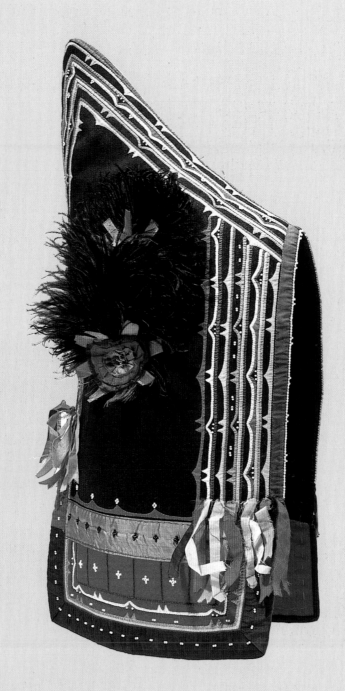

WOMAN'S HOOD

Micmac. Maritime Provinces. c. 1838 or 1847–54. Black and red trade cloth, silk ribbons and trim, dyed ostrich feather, glass beads. 14¾ × 7". T41. Acquired by Lady Mary Louisa Lambton during her Canadian travels in 1838, or while her husband, Lord Elgin, was Governor General of Canada, 1847–54; Earls of Elgin and Kincardine Collection, Scotland

Hoods of this rectangular shape are described by English explorers in the area of Nova Scotia as early as the seventeenth century. The form reached a peak of ornamentation during the first half of the nineteenth century and passed out of fashion by 1875.

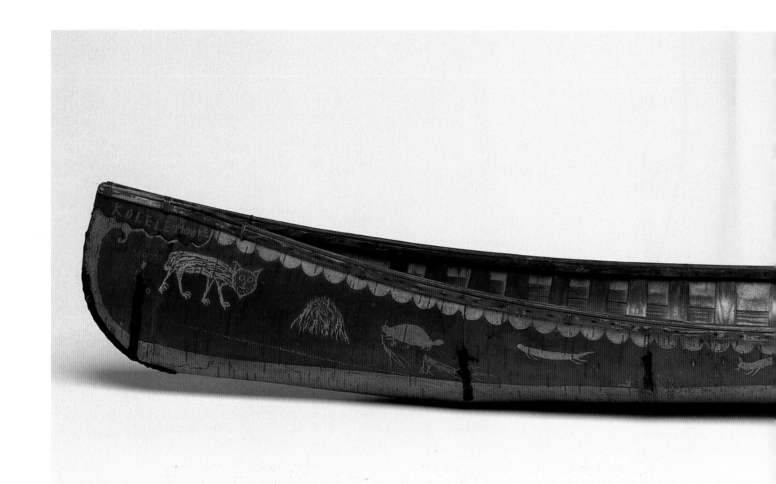

CANOE MODEL

Made by Tomah Joseph (1837–1914). Passamaquoddy Indian Reservation, Peter Dana Point,
Maine. c. 1905. Birchbark, cedar wood, pitch, iron brads. 50½ l. × 10½ w. × 8¼" h. T43.
Private Collection, Arlington, Massachusetts; Skinner's, #1487, January 9, 1993, lot 341

Tomah Joseph, an artist, canoe guide, craftsman, and storyteller, created a new figural
and pictorial style in the abstract floral tradition of Passamaquoddy birchbark art. He
often included inscriptions in Passamaquoddy on his work: Kolele Mooke, meaning
good luck, is seen on the bow.

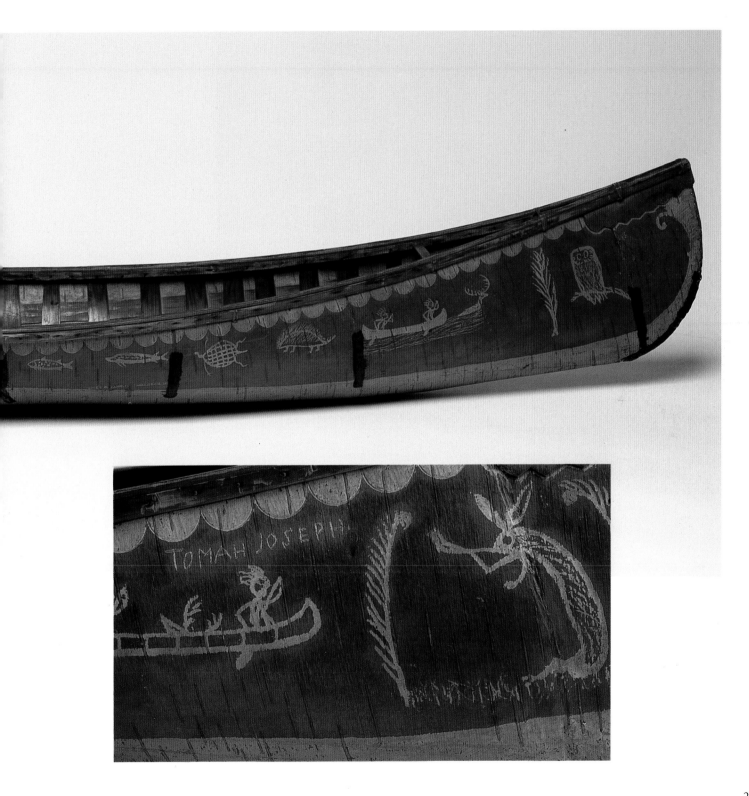

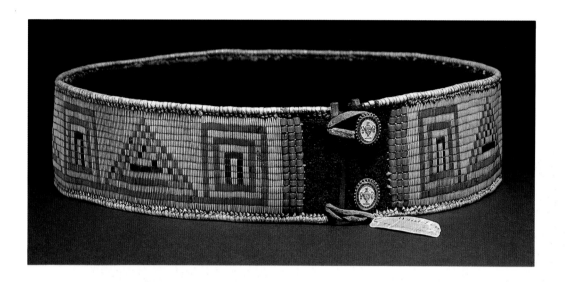

BELT

Manitoba Ojibwe? c. 1800. Hide, blue trade cloth, wooden sticks, porcupine quills, glass beads, enameled metal buttons. 24¾ l. × 2⅛″ w. T44. Wellcome Museum, London; Walter M. Banko, Montreal; Jonathan Holstein, Cazenovia, New York

Belts of this type were produced on a bow loom in which flattened quills were inserted between the warp threads and folded over and under the weft thread. The introduction here of English metal neoclassical buttons into the geometric quillwork pattern has produced a belt of extraordinary beauty, the two different cultures complementing each other well.

SHOTPOUCH

Red River Ojibwe. Manitoba/Ontario. c. 1830. Skin, porcupine quills, wool tassels. 10½ h. × 8 w. × 2″ depth. T45. De Menil Collection, Houston, Texas; William E. Channing, Santa Fe

Hide pouches of this type were made by a number of subArctic and Woodlands peoples and were worn suspended from a neckstring. The pocket held ammunition for muzzle-loaders: this form went out of style by 1860 with the introduction of cartridge rifles. The quillwork floral patterns at the top and the red and white banding along the sides are characteristic of the Manitoba Ojibwe.

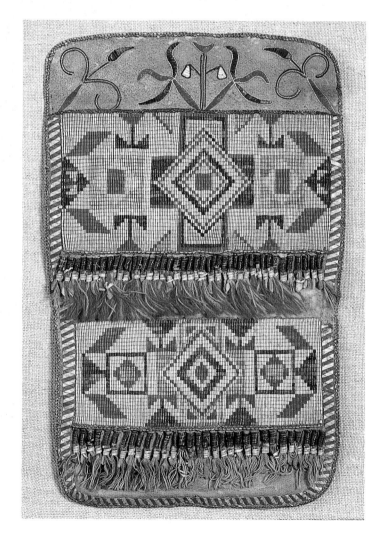

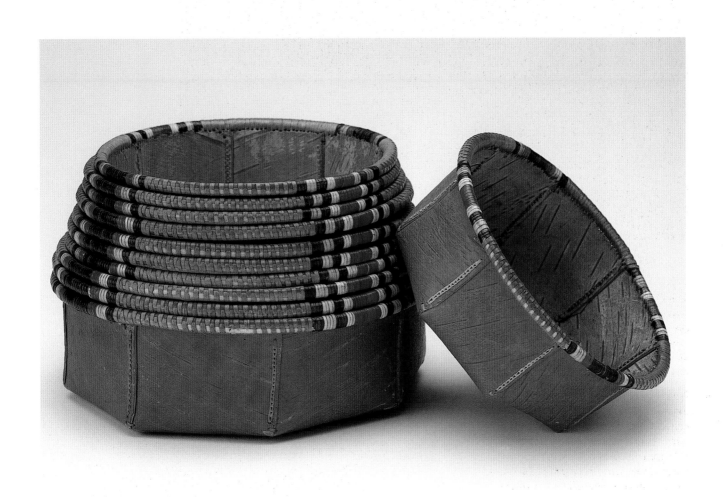

SET OF 11 NESTED BARK BASKETS

Montagnais type. Quebec. c. 1838 or 1847–54. Birchbark, spruce root, porcupine quills. Ranging from 7½ to 5½″ diam., each 2¼″ h. T47. Acquired by Lady Mary Louisa Lambton during her Canadian travels in 1838, or while her husband, Lord Elgin, was Governor General of Canada, 1847–54; Earls of Elgin and Kincardine Collection, Scotland

A superb mastery of birchbark construction is evident in the successive sizing of eleven baskets. This example survives in nearly pristine condition. One other set of nested baskets is in the British Museum.

PLAINS

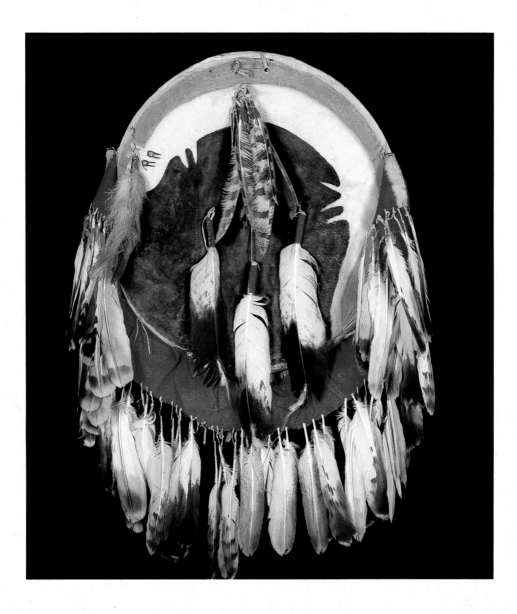

SHIELD

Crow. Montana. c. 1860. Buffalo rawhide, antelope skin, red tradecloth, eagle and hawk feathers, porcupine quills, pigments. 22½″ diam. T48. The earliest remembered owner is Mountain Lion Crossways; his son, Spotted Mountain; his brother, Buffalo That Bellows; Bad Man, the son of Spotted Mountain; William Wildschut, a collector for the Museum of the American Indian/Heye Foundation, New York, 1920; R. Huber in exchange, in 1970; D. J. Petersen, in 1977; Howard B. Roloff, Victoria, British Columbia, in 1980; Elaine Horwitch, Santa Fe; James Havard, Santa Fe

Rawhide shields were one of the Plains warrior's most sacred possessions. Designs were derived from dreams or visions. Because imagery was given by spirits of the sky, shields were never allowed to touch the ground. After the introduction of firearms, shields acquired more power as spiritual guardians than as physical protection.

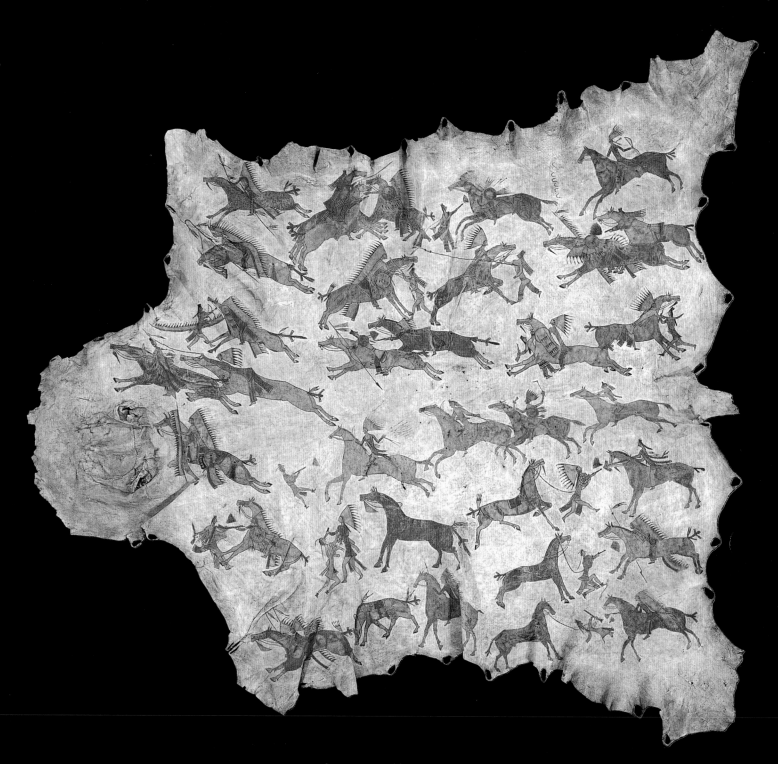

PAINTED HORSEHIDE

Western Lakota. North or South Dakota. c. 1880, Horsehide, pigments; branded. 98 × 93".
T49. Museum of the American Indian/Heye Foundation, in 1919; Robert L. Stolper, Munich,
Germany and New York in 1973; Michael Kern Collection, Dresden, Germany; Morning Star
Gallery, Santa Fe

By the late nineteenth century, pictographic painting had evolved into a realistic and
color-filled picture writing. The images on this horsehide, recording warfare between
the Lakota and Crow, were drawn by one or more Lakota warriors. The skin may be
from one of the horses depicted in the drawing.

PARFLECHE

*Cheyenne. Montana or Oklahoma. c. 1830. Buffalo rawhide, color
pigments. 27 × 19". T51. George Terasaki Collection, New York;
Trotta-Bono, Shrub Oak, New York*

Envelope-shaped parfleches are the most characteristic rawhide
containers of the Plains Indians. The use of red and green
pigment outlined in black is found on parfleches produced
before 1850. The composition in this example is unusually bold.

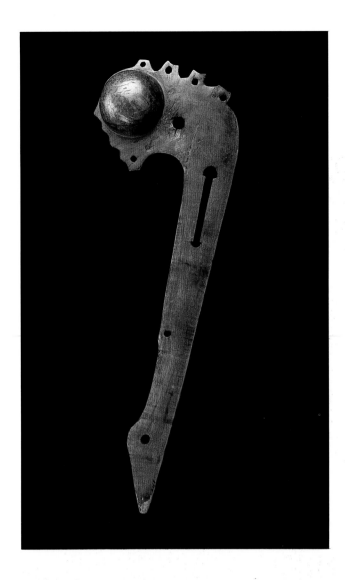

WAR CLUB

Eastern Lakota. Minnesota Region. c. 1815. Wood. 20½ l. × 3½ w. × 6¾" depth . T54. George Terasaki Collection, New York; Sotheby's, #6061, September 25, 1990, lot 219; Gary Spratt, Rutherford, California; Morning Star Gallery, Santa Fe

Clubs were traditional weapons and remained popular even after the introduction of firearms because they were associated with the greater honor of hand-to-hand combat and retained a sacred nature. Generally classified as ball-headed, this type of war club is identified with the Eastern Lakota because of the slanting terminal on the handle and the cut-out using a rectangular space between two circles.

HORSE DANCE STICK

Teton Lakota. North or South Dakota. c. 1880. Wood, iron and brass tacks, red trade cloth, glass beads, human scalp, horse hide with hair. 38 l. × 4¼" w. T55. A Midwestern Museum; Christopher Selser, Santa Fe

The arrival of the horse transformed Plains life and culture. Horses offered new mobility in hunting and warfare to a younger generation and a good deal of paraphernalia evolved around the animal, including effigies carried in victory dances by successful horse-raiders and used by members of Horse Societies in their ceremonials.

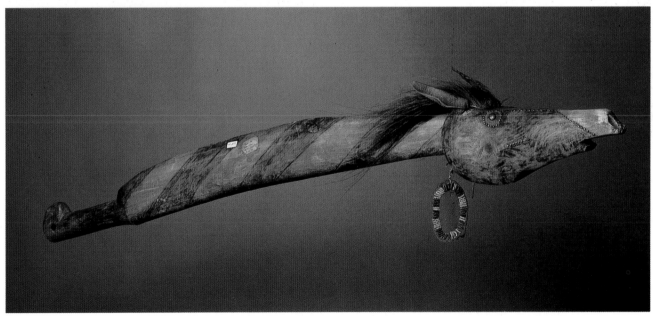

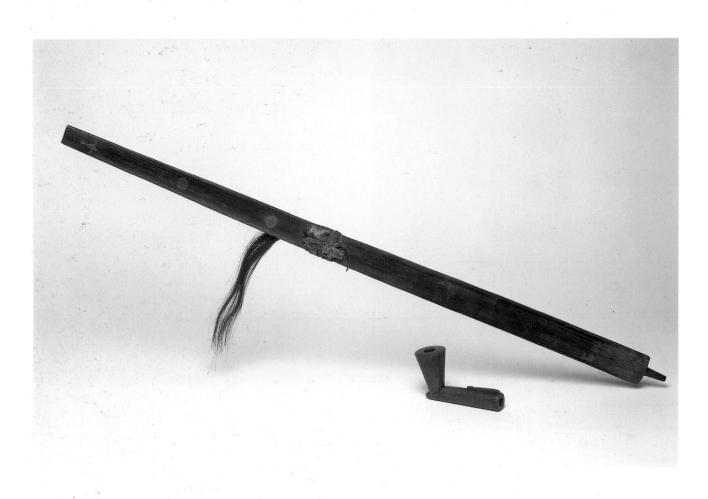

CEREMONIAL PIPE

Eastern Lakota type. Minnesota. c. 1820. Wood, catlinite, horsehair, woodpecker scalp and beak, mallard feathers, buckskin strings, lead inlay, red and black pigments. Stem 40¼" l.; bowl 3¼ h. × 5¾" l. T53. Acquired by R. VandenBergh at Crow Agency trading post, Montana; Toby Herbst, Santa Fe

Pipes are used at important events. This example has a stylized thunderbird carved near the mouthpiece with a zigzag line running to circular images of the sun and moon. A beak and scalp of a pileated woodpecker are tied above and mallard feathers and red-dyed horsehair are attached below. The dark patina of the wood suggests many years of use. The pipe is spiritually empowered when the two parts are joined.

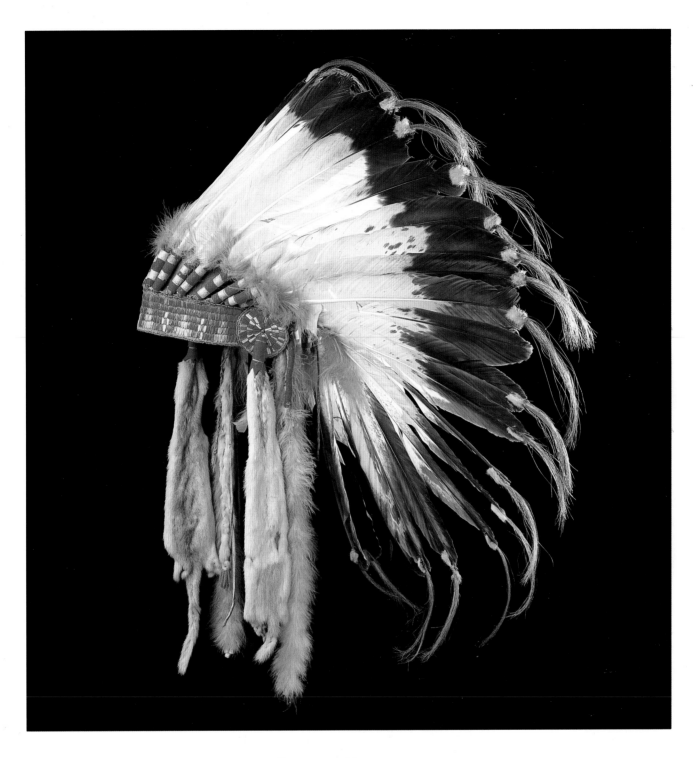

FEATHER HEADDRESS

Teton Lakota. North or South Dakota. c. 1900. Eagle feathers, felt, porcupine quills, red trade cloth, glass beads, yarn, animal skins, horsehair. 26 × 20″. T60. Pierre Bovis, Santa Fe; Alderman Collection, Connecticut; Morning Star Gallery, Santa Fe

Feather headdresses, a distinctive ornamental headgear of the Plains Indians, have been popularized throughout the rest of the world as a symbol of all North American Indians. Originally, they were manifestations of leadership, each feather being awarded for a specific action.

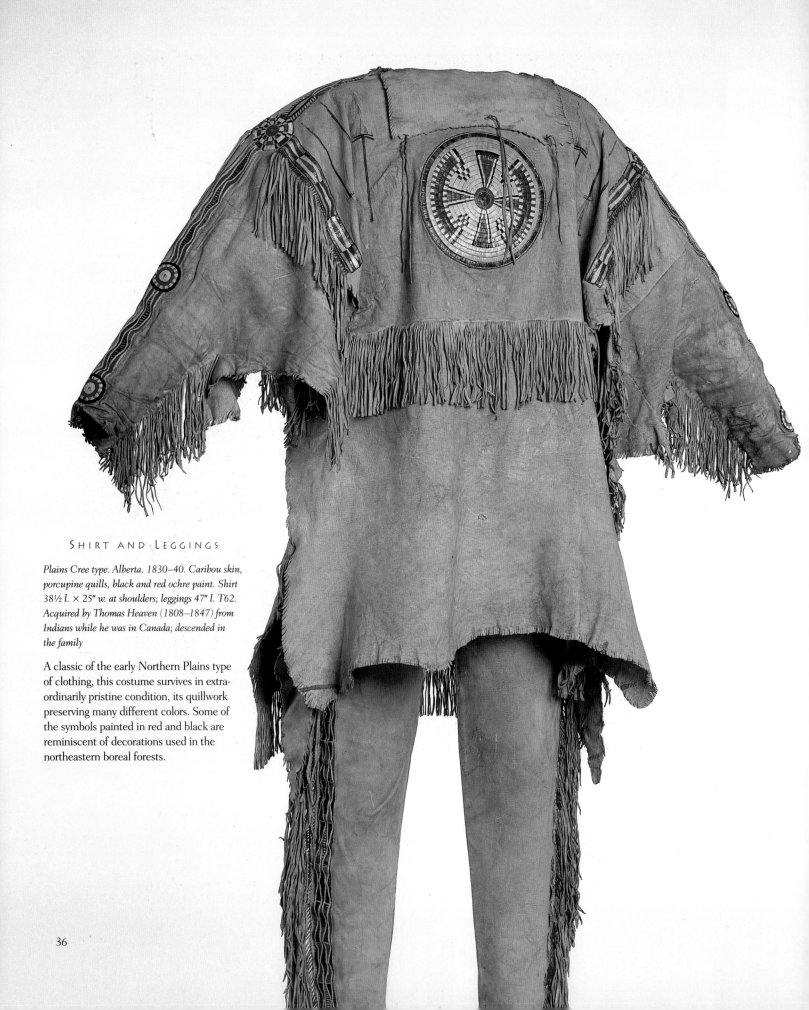

SHIRT AND LEGGINGS

*Plains Cree type. Alberta. 1830–40. Caribou skin,
porcupine quills, black and red ochre paint. Shirt
38½ l. × 25" w. at shoulders; leggings 47" l. T62.
Acquired by Thomas Heaven (1808–1847) from
Indians while he was in Canada; descended in
the family*

A classic of the early Northern Plains type
of clothing, this costume survives in extra-
ordinarily pristine condition, its quillwork
preserving many different colors. Some of
the symbols painted in red and black are
reminiscent of decorations used in the
northeastern boreal forests.

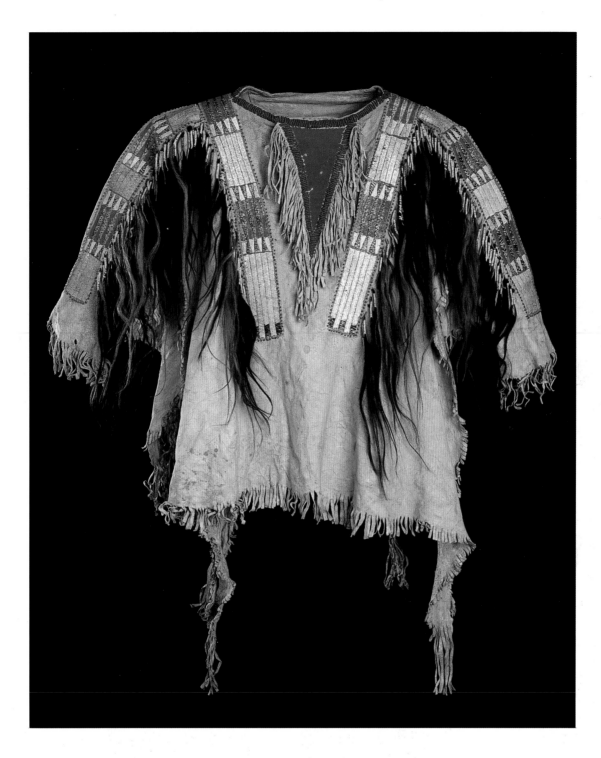

MAN'S SHIRT

Teton Lakota. South Dakota. c. 1870. Antelope hide, porcupine quills, pony beads, red trade cloth, human and horsehair tassels, sinew thread. 43 l. × 56½" wide across the arms . T64. Acquired by Major John Cook, government agent at the Rosebud Indian reservation, Dakota Territory, in 1880; Greg Thorne Collection, Los Angeles; Richard A. Pohrt Collection, Flint, Michigan; Private Collection, New Jersey; Sotheby's, #6297, June 12, 1992, lot 130 (prior to this auction red trade cloth and hair tassels were restored)

Shirts of this design, with quillwork strips outlined by tassels of hair or hide, used to be the exclusive regalia of high rank-ing and respected members of Plains tribes. A photograph taken in 1867 shows Tall Mandan, a Teton Lakota, wearing a very similar shirt.

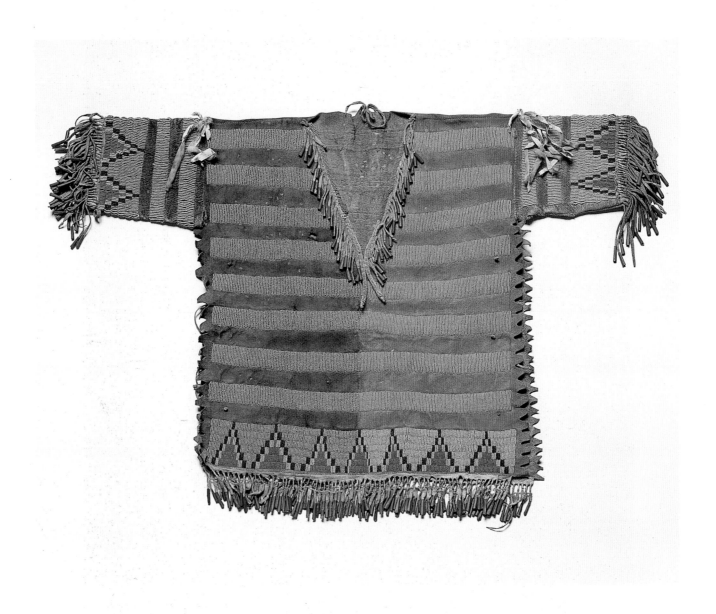

BOY'S SHIRT

Blackfeet, possibly Assiniboine. Montana or Saskatchewan. c. 1870. Buffalo skin, glass and gourd beads, pigment, porcupine quills, rabbit fur, tin cones. 35″ l. T65. Private Collection, Canada; William E. Channing, Santa Fe; Jonathan Holstein, Cazenovia, New York

Finely decorated garments such as this shirt were made for selected children of wealthy parents. The Blackfeet called these favored children Minipoka and their beautiful garments, toys, ponies, and play tipis proclaimed the prestige of their parents.

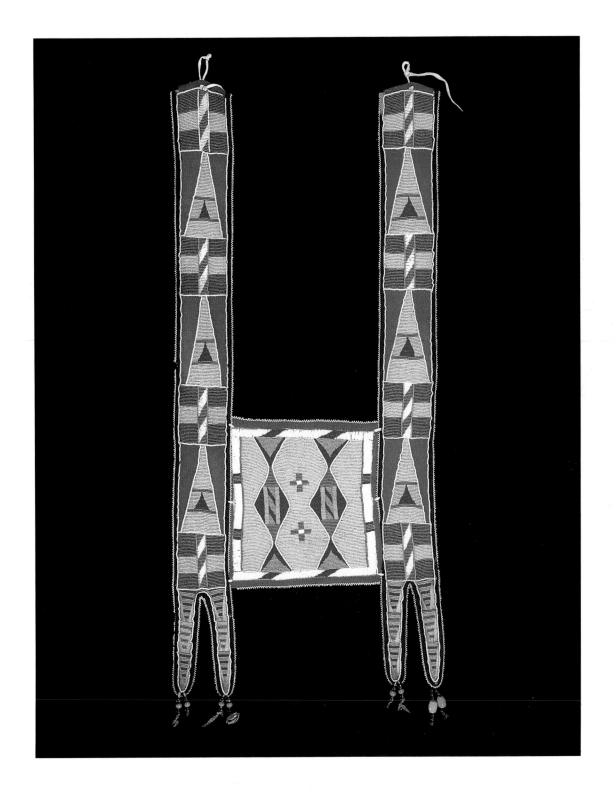

MARTINGALE

Crow. Montana. c. 1885. Bison hide, red trade cloth, blue trade cloth, glass beads, brass bells. 34½ l. × 14½″ w. T74. Kenneth Canfield, Santa Fe

Martingales are part of the decorative regalia that adorned horses on ceremonial occasions. The stitching technique and geometric designs outlined in strings of single white beads are distinctive features of Crow craftsmanship.

CRADLE

Kiowa. Southern Plains. 1880–1900. Hide, glass beads, wood, German silver tacks, red trade cloth, cotton. 39½ × 12¾″. T77. F. Llewelyn Casterline Collection, Belmont, New York; Skinner's, Fall 1990; Morning Star Gallery, Santa Fe

The nomadic Plains Indians needed cradles to carry their young children on long journeys. The long skin bag attached to a wooden frame of two long slats held at an angle by crosspieces was developed by the Kiowa and spread to the Comanche, Cheyenne, and Western Lakota. The abstract beadwork designs may have been inspired by stylized floral patterns brought to Oklahoma by relocated eastern tribes.

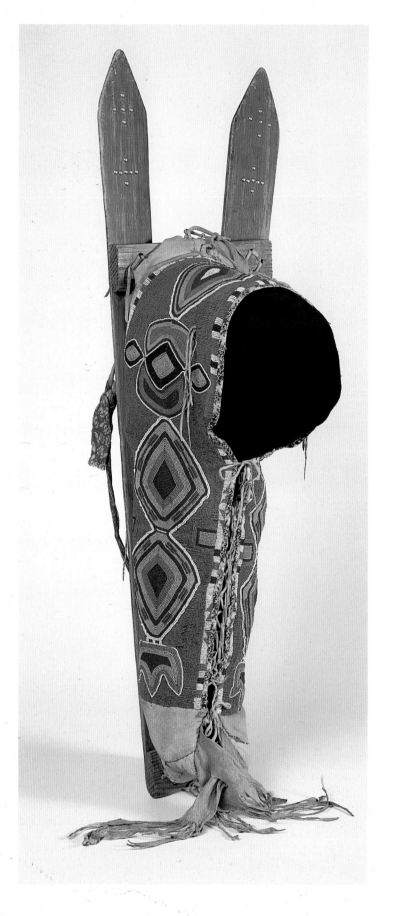

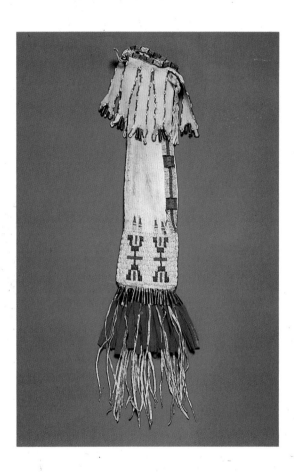

PIPE BAG

Cheyenne. Montana or Oklahoma. 1860–70. Antelope hide, glass beads, metal cones, strips of red trade cloth (restored). 16 l. (excluding fringe) × 4¼″ w. T76. H. Malcolm Grimmer Collection, Santa Fe

Pipe bags often held the owner's pipe bowl, pipe stem, tobacco, and other important objects. Long edge-beaded tabs around the upper rim are characteristic of Cheyenne design.

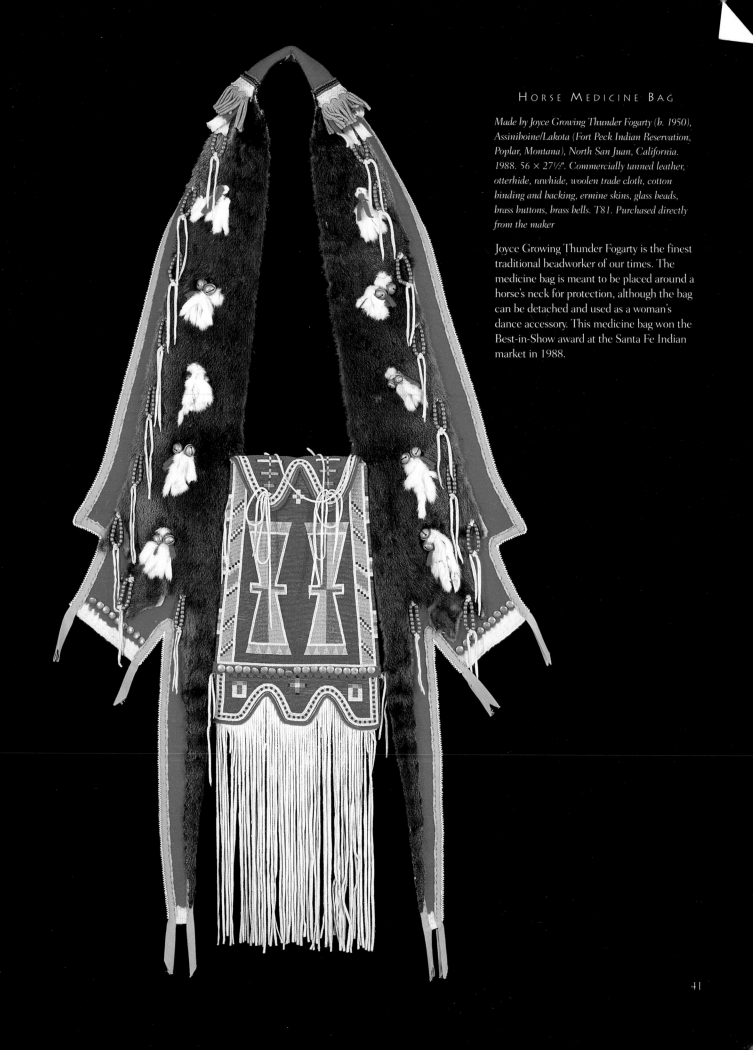

HORSE MEDICINE BAG

Made by Joyce Growing Thunder Fogarty (b. 1950), Assiniboine/Lakota (Fort Peck Indian Reservation, Poplar, Montana), North San Juan, California. 1988. 56 × 27½″. Commercially tanned leather, otterhide, rawhide, woolen trade cloth, cotton binding and backing, ermine skins, glass beads, brass buttons, brass bells. T81. Purchased directly from the maker

Joyce Growing Thunder Fogarty is the finest traditional beadworker of our times. The medicine bag is meant to be placed around a horse's neck for protection, although the bag can be detached and used as a woman's dance accessory. This medicine bag won the Best-in-Show award at the Santa Fe Indian market in 1988.

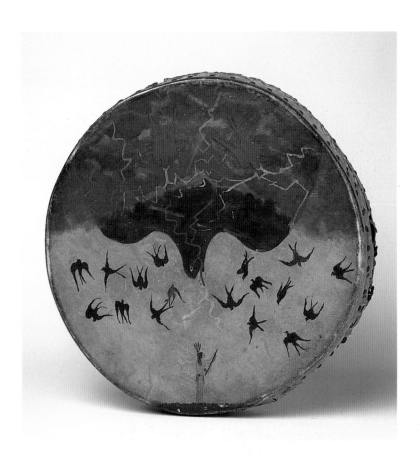

DOUBLE-SIDED DRUM

Pawnee. Oklahoma. c. 1890. Rawhide, wooden hoop, iron nails and tacks, pigments. 18 diam. × 3½" depth. T86. George Terasaki Collection, New York

Three drums are known that utilize this distinctive scene of a thunderbird descending from black clouds, shooting lightning from its eyes or beak, and stirring up swallows. The drums are said to be associated with the Pawnee Ghost Dance hand games around the turn of the century.

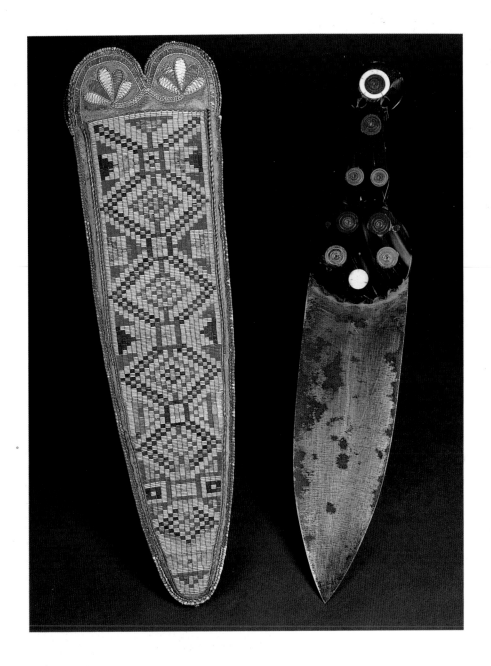

TRADE KNIFE AND SHEATH

Red River Ojibwe. Manitoba. c. 1830. Steel, African buffalo horn, brass and bone fittings, buckskin, porcupine quills. 13¾". T88. Beasley Collection, England; A. Cooper, England; Donald W. S. Donald, London, in 1952; Sotheby's, #6297, June 12, 1992, lot 118; Alan S. Cook, Surrey, England; Taylor A. Dale, Santa Fe

The extraordinary quality of the loom-woven quillwork sheath as well as the horn-handled trade knife suggest that this sheath and knife were commissioned as a presentation piece for an important Indian client of the Hudson's Bay Company.

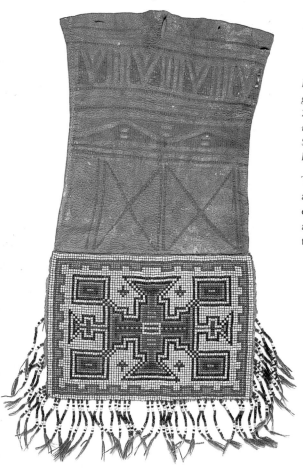

PANEL BAG

Red River Ojibwe. Manitoba. c. 1790. Buffalo hide, glass beads, pigment paint, yarn tassels, sinew thread. 23 × 11". T89. Acquired in the nineteenth century by a member of the McHaffie-Gordon family, Wigtownshire, Scotland; Private Collection, Edinburgh, Scotland; Phillips Auctions, London; Walter M. Banko, Montreal

The combination of a painted buffalo skin pouch above a loom-woven beaded panel is a rare and early example of a type of belt pouch that later acquired widespread popularity from James Bay to the Columbia and Yukon Rivers.

PANEL BAG

Red River Métis. Manitoba. c. 1820. Red trade cloth, silk ribbon, silk thread, beads. 17½ l. × 13" w. T91. Derumeau Collection, Paris; Walter M. Banko, Montreal; Jonathan Holstein, Cazenovia, New York

In the western fur trade country, this type of container was called a fire bag as it held the flint and steel for starting a fire. These bags also served other functions, such as carrying a pipe and tobacco.

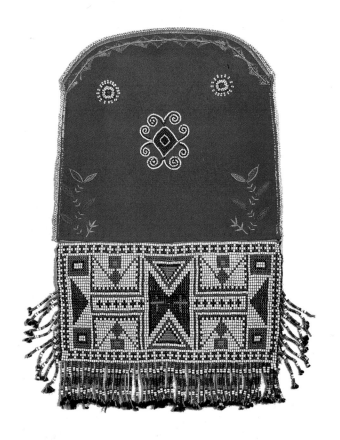

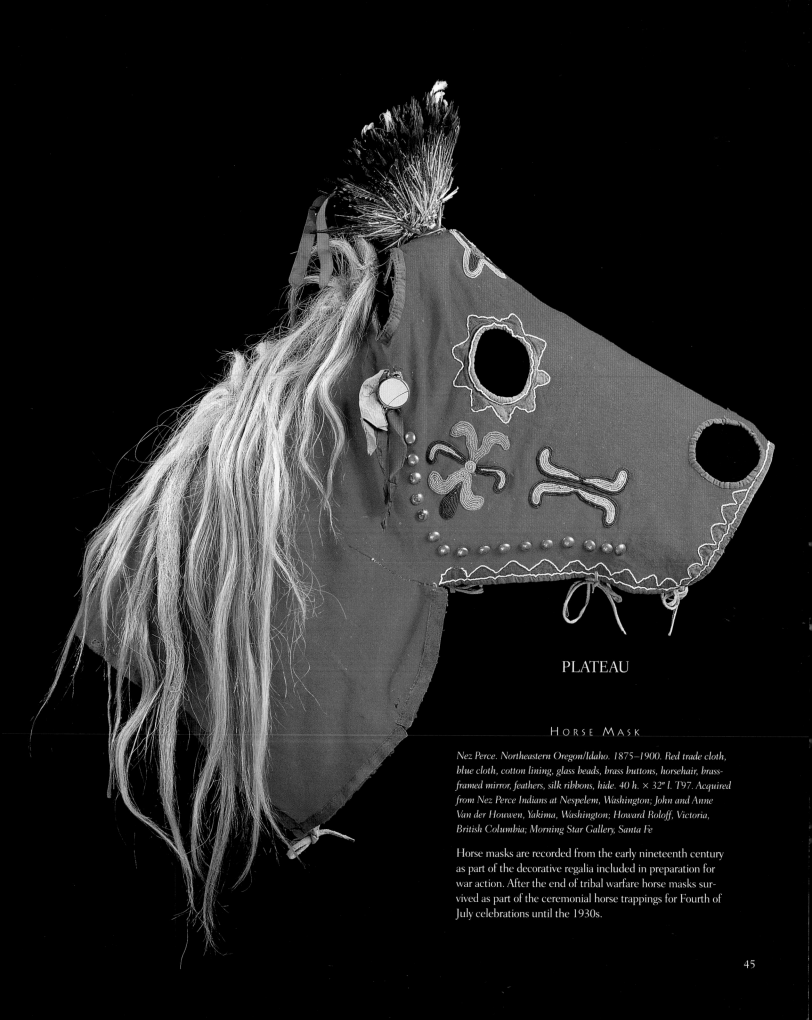

PLATEAU

HORSE MASK

Nez Perce. Northeastern Oregon/Idaho. 1875–1900. Red trade cloth, blue cloth, cotton lining, glass beads, brass buttons, horsehair, brass-framed mirror, feathers, silk ribbons, hide. 40 h. × 32″ l. T97. Acquired from Nez Perce Indians at Nespelem, Washington; John and Anne Van der Houwen, Yakima, Washington; Howard Roloff, Victoria, British Columbia; Morning Star Gallery, Santa Fe

Horse masks are recorded from the early nineteenth century as part of the decorative regalia included in preparation for war action. After the end of tribal warfare horse masks survived as part of the ceremonial horse trappings for Fourth of July celebrations until the 1930s.

SOUTHWEST

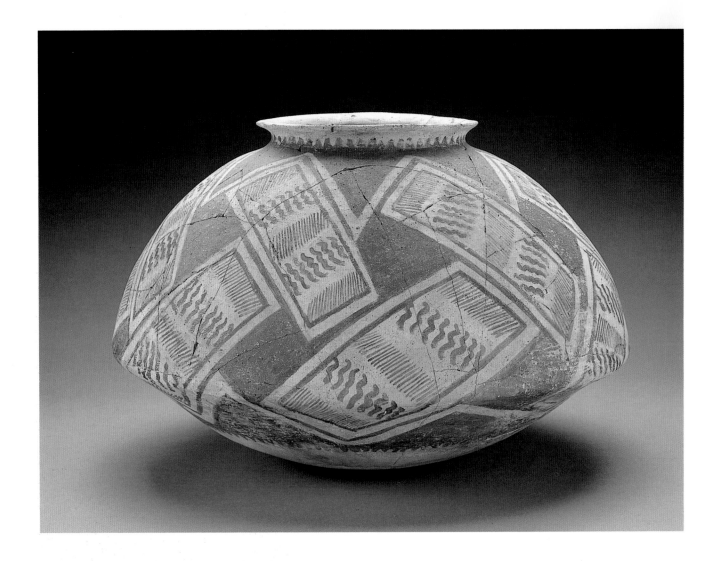

JAR

Hohokam. Southwestern Arizona. A.D. *900–1100. Ceramic.
11½ h. × 18½" diam. T98. Jordan Davis, Santa Fe; Morning Star
Gallery, Santa Fe*

The Hohokam were an agricultural people centered in the
desert region of southwestern Arizona. They were ancestral
to the modern O'Odam (Pima, Papago). Jars of this low-
shouldered shape are unique to the Hohokam and may have
been used for storage of foodstuffs, for ceremonial purposes,
or for cremations. They were made by coiling in the paddle
and anvil technique.

Salado. Central Arizona. A.D. 1200–1400. Spondylus princeps broderip shell, turquoise and shell beads, jet, turquoise and other stones. Pendant 4 h. × 4½ w. × 1½″ depth; necklace 14″ l. T101. Anthony Berlant, Los Angeles, California; Xavier Fourcade, New York

Colorful pendants combining spiny oyster shells from the Pacific and turquoise from the Southwest were made both by the Hohokam (300 B.C.–A.D. 1450) and the Salado (c. A.D. 1100). The presence of oceanic shells so far inland demonstrates the existence of extensive ancient trade routes.

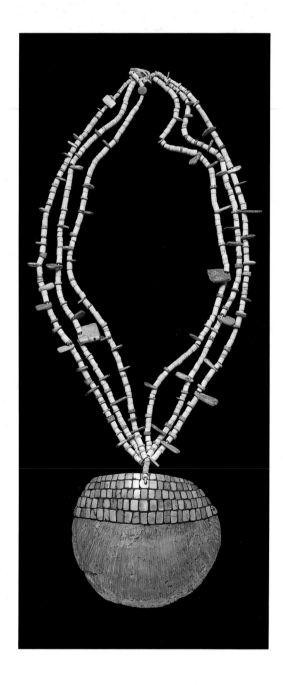

PICTORIAL BOWL

Mimbres. Southwest New Mexico. A.D. 1000–1150. 4 h. × 8″ diam. Ceramic, organic pigment. T99. J. V. Desvaux; Morning Star Gallery, Santa Fe

Mimbres culture is celebrated for its pottery with highly refined pictorial images showing details from daily life. Among the Mimbres dogs were used in hunting, and that may be the intended reference to this pair wearing collars.

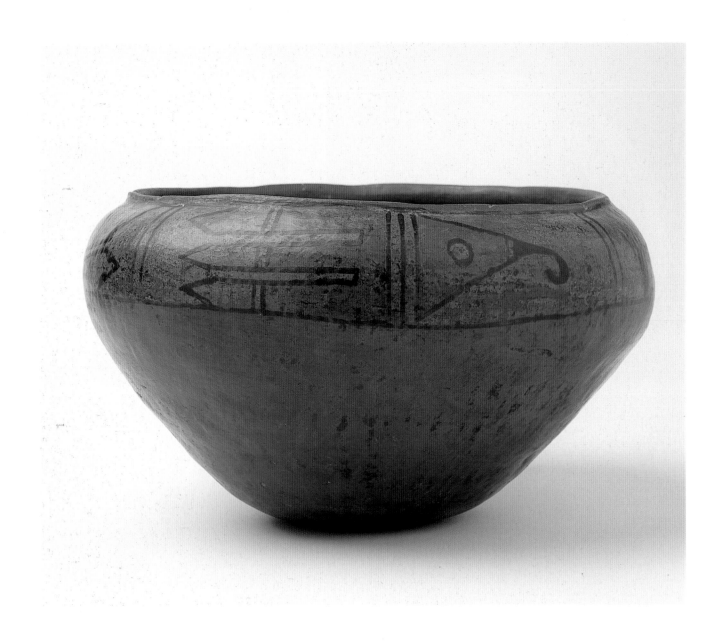

POLYCHROME BOWL

Ako (Acoma/Laguna). Northwestern New Mexico. 1700–50. 7¾ h. × 13¼" diam. Ceramic, mineral pigments. T102. Purchased at Acoma Pueblo, New Mexico; Olive Rush Collection, Santa Fe; Dennis Lyon Collection, Scottsdale, Arizona; Richard Spivey, Santa Fe

Even after hundreds of years each pueblo of the Southwest maintains its own distinctive ceramic forms and decorative symbols. A rare early bowl with a painted band composed of two stylized birds, this is a precursor of the modern ceramics from Acoma and Laguna pueblos.

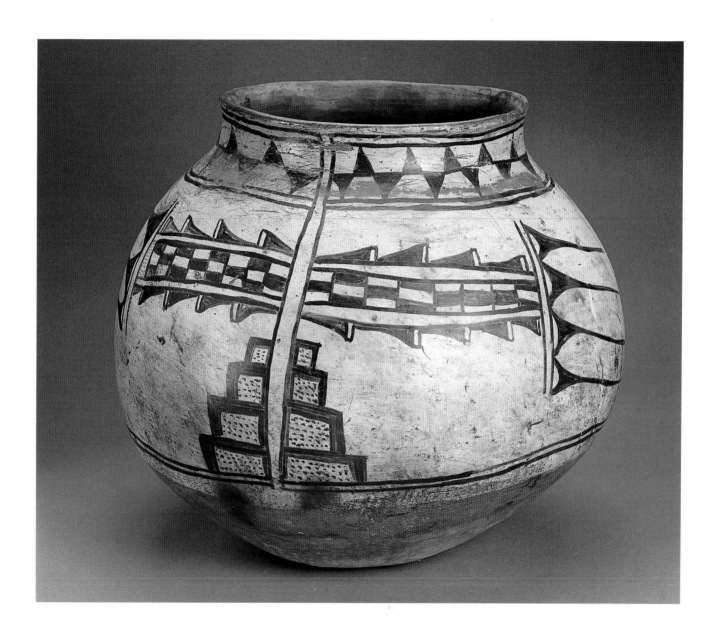

P O L Y C H R O M E J A R

Kiua. Santo Domingo or Cochiti. Upper Rio Grande Valley, New Mexico. 1800–80. Ceramic.
17¼ h. × 19¼″ diam. T113. Larry Frank, Arroyo Hondo, New Mexico.

The Kiua design is ancestral to most of the fine pottery being made at Santo Domingo
and Cochiti pueblos today. In addition to a slip of rag-polished bentonite clay and a
globular body, typical Kiua design features include red banding above and below the
decoration and a top-to-bottom break in the pattern.

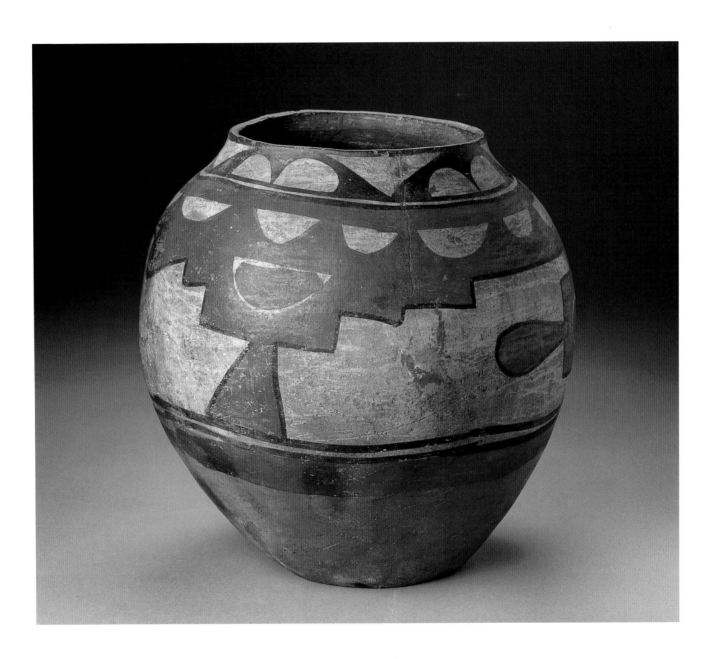

POLYCHROME JAR

Santa Ana. Jemez River, Rio Grande Valley, New Mexico. c. 1830. Ceramic. 11 h. × 12" diam.
T111. Robert V. Gallegos Collection, Santa Fe; Morning Star Gallery, Santa Fe

Early nineteenth-century Santa Ana pottery jars have bulbous bodies with short necks.
The simple bold decorative motifs often are enclosed between framing lines and dark
red patterns outlined with black on a gray-white slip.

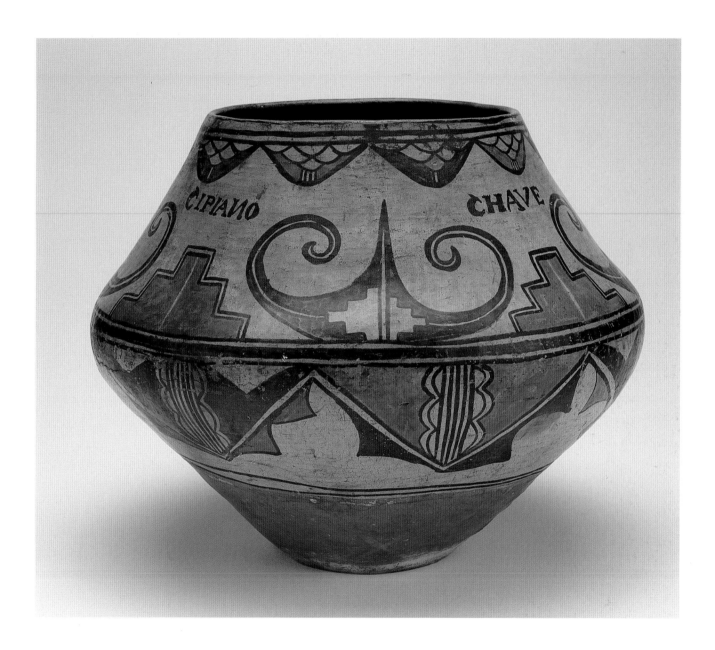

POLYCHROME JAR

*Attributed to Martina Vigil and Florentino Montoya. San Ildefonso. Upper Rio Grande Valley,
New Mexico. c. 1900. Ceramic. 10½ h. × 12¾″ diam. T115. Paul Sarkisian, Santa Fe*

The graceful shape and curvilinear painted designs are typical of the pottery made
between 1890 and 1910 by Martina Vigil and Florentino Montoya, gifted and influential
potters at San Ildefonso Pueblo. The name Cipiano Chave[z] on the vessel probably
indicates that it was made on commission.

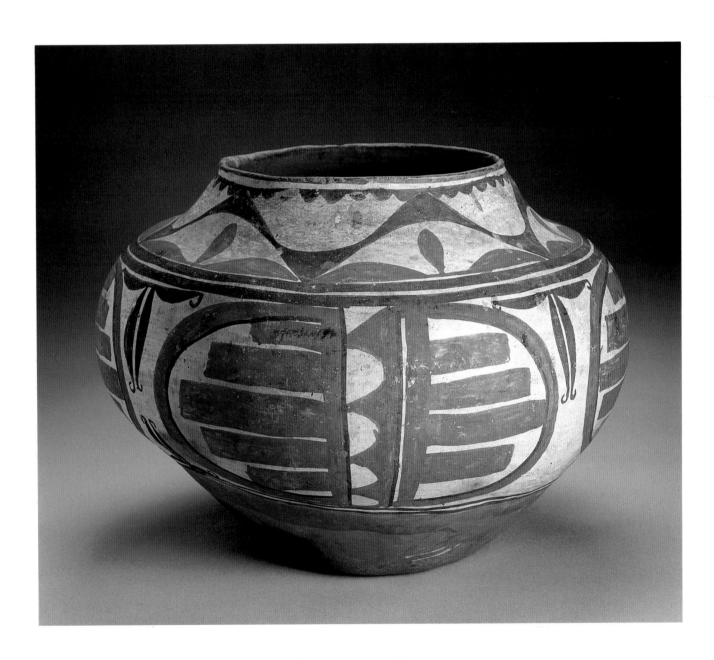

POLYCHROME JAR

Zia or Trios Polychrome. West-Central New Mexico. c. 1840. Ceramic. 9½ h. × 13¼″ diam.
T117. Robert V. Gallegos Collection, Santa Fe; Morning Star Gallery, Santa Fe

The red "fingers" and white scallops resemble designs from nearby Santa Ana Pueblo,
but pottery from Zia Pueblo can be identified by the distinctive specks of crushed
black rock temper added to the clay, a technique abandoned by the other pueblos in
the 1400s.

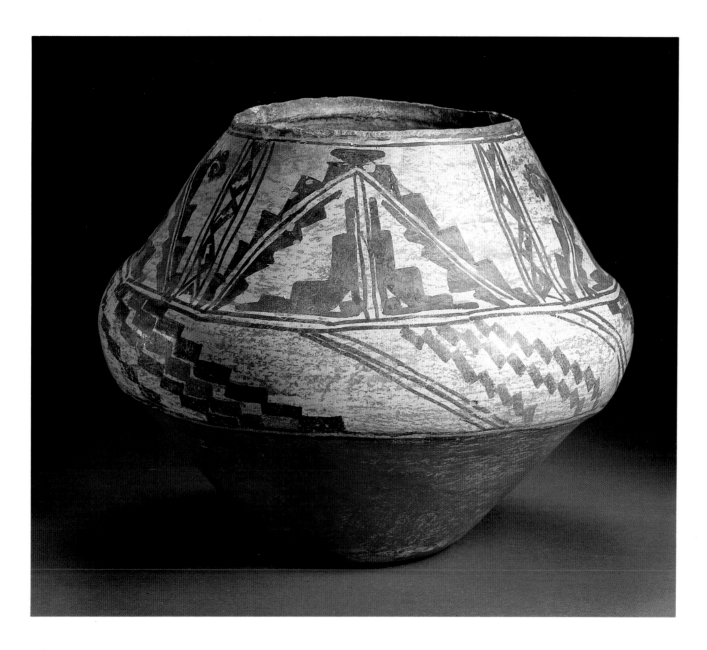

POLYCHROME JAR

Ashiwi (Zuni). Western New Mexico. c. 1725. Ceramic. 9½ h. × 12″ diam. T119. Frank Harlow,
Los Alamos, New Mexico; Robert V. Gallegos Collection, Santa Fe; Rick Dillingham, Santa Fe

The mid-body bulge and long sloping neck ending with a slight flare on this jar is
characteristic of Ashiwi pottery, a type made at Zuni Pueblo between 1700 and 1750.

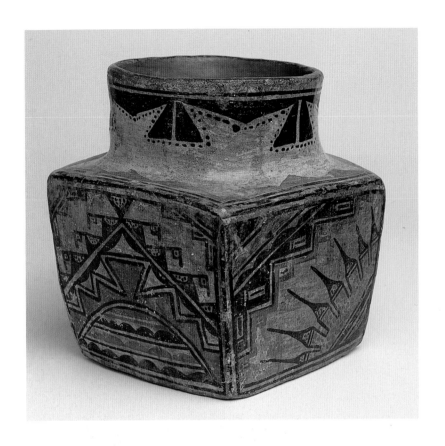

*Santa Ana or Zia? Jemez River, Rio Grande Valley,
New Mexico. 1780–1820. Ceramic. 6 × 6". T110.
Private collection, California; Dewey Galleries,
Santa Fe; Al Luckett, Jr., Santa Fe*

A remarkable vessel in both its square shape
and unique black and red designs this jar is
matched by only one other known example;
its use or purpose has not been determined.

JAR

*Zuni. New Mexico. 1870–85. Ceramic. 9¾ h. ×
11" diam. T120. W. S. Dutton, Santa Fe*

Zuni potters developed a ceremonial pot in the
1860s that featured frogs emerging from the
high shoulders. This jar is an early example,
but is a notable exception by incorporating
owl heads. Frogs are clearly associated with
water symbology, but the meaning of the owl
is unknown.

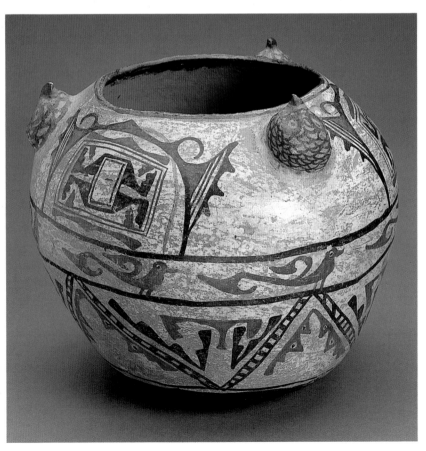

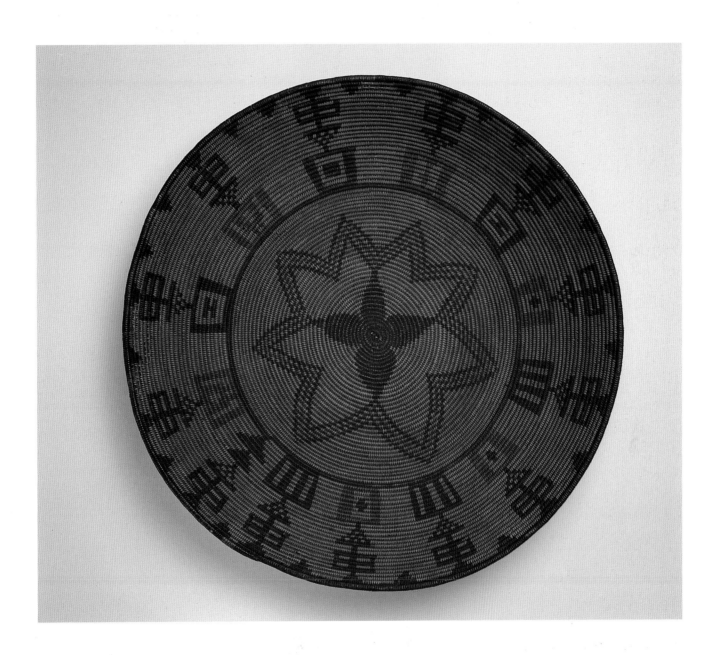

TRAY

Western Apache. Arizona. c. 1915. Wooden rods, willow or cottonwood splints, devil's claw, yucca root. 4¼ h. × 19¾" diam. T130. Claire Zeisler Collection, Chicago; Morning Star Gallery, Santa Fe

Large shallow trays were used originally for winnowing or parching seeds, but by the turn of the century they were being made to sell to collectors and tourists. The irregular spacing in the outer circle and in the central star is common in Apache symbolism.

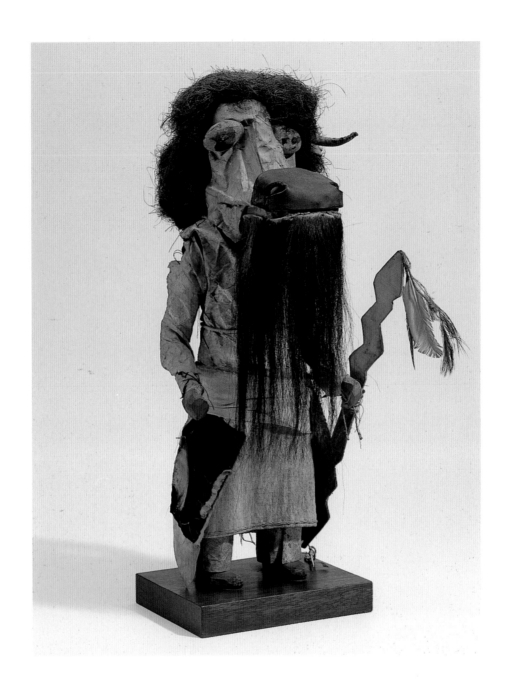

BUFFALO KACHINA DOLL (SIWOLO)

Zuni. Western New Mexico. 1900–10. 16 h. × 8 w. × 6¼″ depth. Hide and leather, hair, roots, wood, cotton, feathers, silk, pigments, string. T121. Claire Zeisler Collection, Chicago; Morning Star Gallery, Santa Fe

Attributes of the Buffalo kachina include a mask with a long snout, globular eyes, a lightning stick, and a rattle (now missing in this example). The addition of fabrics and hair to the wooden body and the articulated arms is characteristic of Zuni kachina dolls made before World War II. The Buffalo kachina appears in the Sioux Winter Dance.

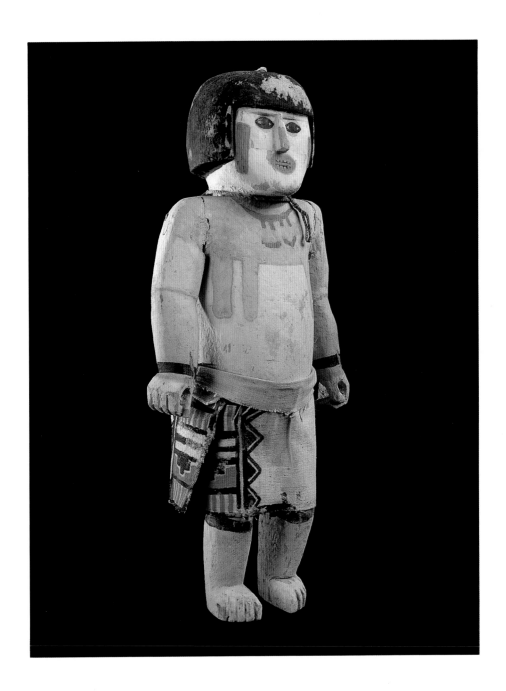

WUTAKA OR OLD MAN KACHINA DOLL

Hopi. Arizona. c. 1915. Wood, gesso, paint, linen or cotton cloth, wire nails, string. 21½ h. × 10¼ w. × 5″ depth.
T106. John Arieta, London, England; Betty Sterling, Randolph, Vermont and Honolulu, Hawaii; John Hill,
Phoenix, Arizona; Shaw Gallery, Aspen, Colorado.

In the Southwestern pueblo religions kachinas are spirits representing different human qualities, plants, animals, or natural phenomena. They are symbolized by masked dancers who appear in ceremonies between December and July and by effigy dolls traditionally given to children to help them recognize specific spirits. Wutaka represents an old man or grandfather who usually carries a rope or stick and acts as a disciplinarian of younger children.

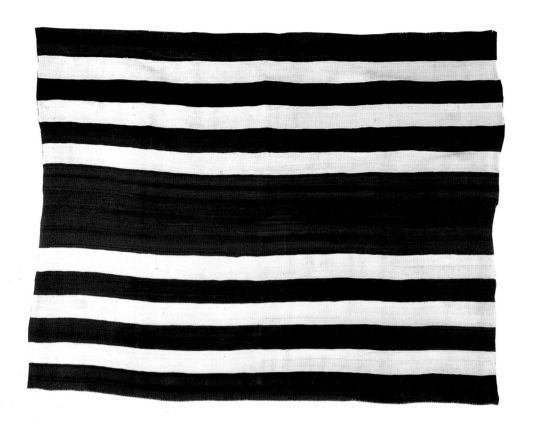

CHIEF BLANKET— FIRST PHASE

Navajo. Arizona. 1840–60. Wool. 64 w. × 48″ l. T122. Juan Hamilton, Abiquiu, New Mexico; Gerald Peters Collection, Santa Fe

The Navajos learned weaving from the Pueblos about 1700 and still use the traditional Pueblo upright loom today. Their earliest wool shoulder blankets or mantas were white or gray with broad horizontal stripes of black and/or indigo blue. They were traded widely and were so especially prized by the Ute Indians that they became known as "Ute blankets."

CHIEF BLANKET— SECOND PHASE

Navajo. Arizona. 1868–75. Wool, cochineal dyed and raveled commercial yarn, orange-red commercial dye. 82 h. × 49″ w. T123. Gerald Peters Collection, Santa Fe

About 1850 colored rectangles of trade yarn were added to the blue/black stripes of the Ute (First Phase) manta. These became known as Second Phase "Chief Blankets" although there were no chiefs among the Navajo. Their brilliant design and fine weaving made them greatly desired by the Plains tribes.

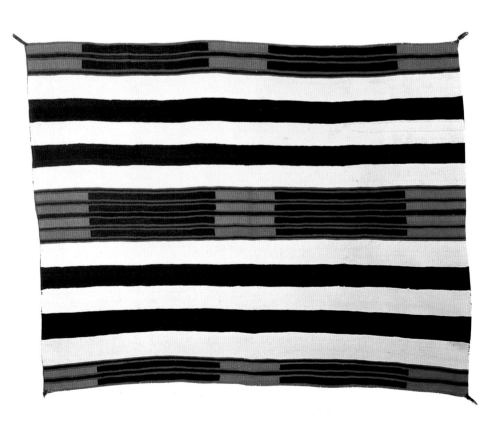

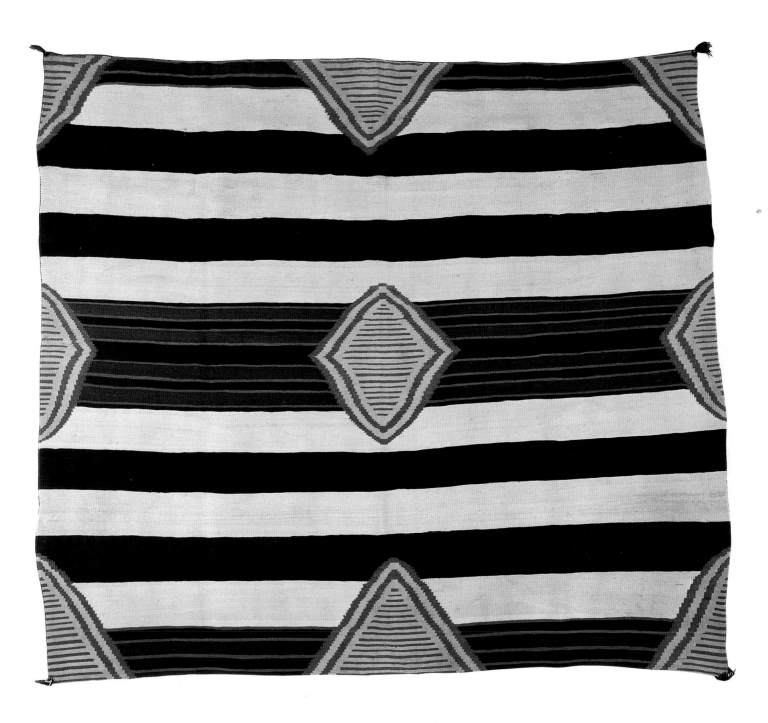

CHIEF BLANKET—THIRD PHASE

Navajo. Arizona. 1855–64. 71 h. × 51″ w. T124. Gerald Peters Collection, Santa Fe

At some time before 1860 a variety of large diamond figures was introduced into the designs of Second Phase Chief Blankets, creating the Third Phase, which lasted until about 1880. The half and quarter diamonds at each edge are joined when the blanket is wrapped around the wearer.

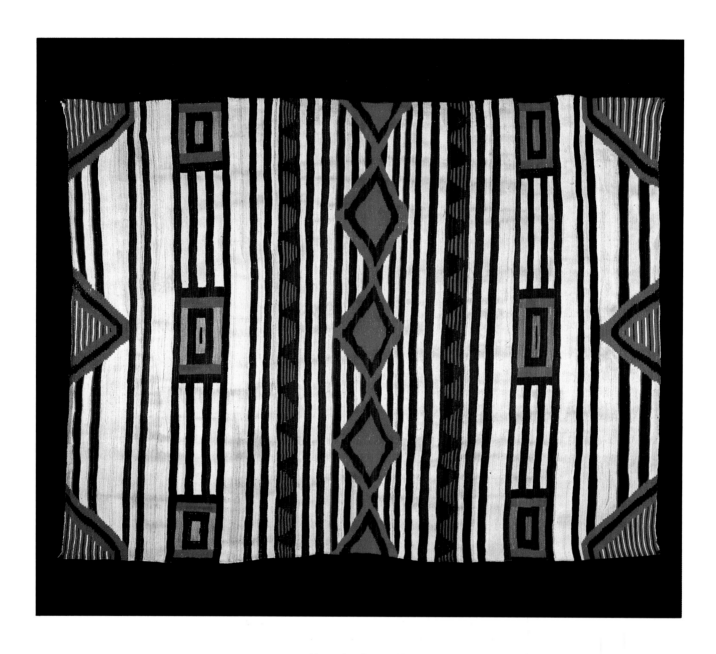

MAN'S SERAPE

Navajo. Arizona. 1840–60. Wool. 50 w. × 39″ l. T125. Gerald Peters Collection, Santa Fe

Serapes were introduced from Mexico, but were woven by the Navajos for many years and used for many purposes. They are longer than wide, and their decorative stripes generally run vertically. Some have central slits so they can be worn as ponchos. Between 1800 and 1865 serapes represented the finest examples of Navajo weaving: tightly woven in brilliant colors.

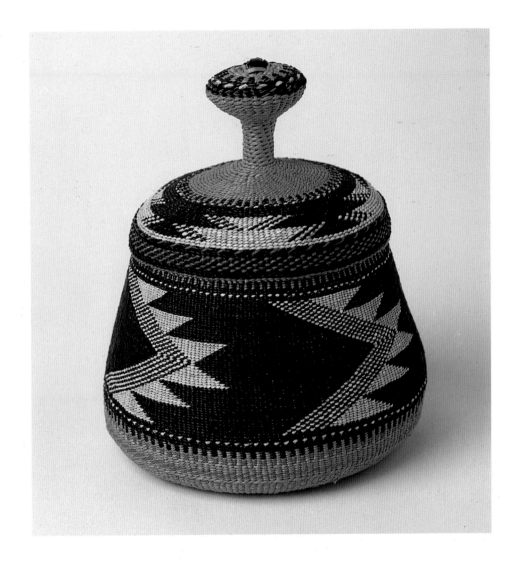

FANCY BASKET

Karok. Woven by Elizabeth Conrad Hickox (1873–1947). Klamath River, Northern California. 1920–35. 3¾ × 4". Bear grass, maidenhair fern, porcupine quills, hazel and pine or alder root, hazel sticks. T135. J. Rauzy; Larry Wendt, Santa Fe

Basketry is an important part of the belief system for the Karok, Hupa, and Yurok people, and Elizabeth Conrad Hickox is one of the greatest artists in the California basketry tradition. Much of her work is composed of small "fancy" baskets, a term for baskets incorporating black maidenhair fern stems, a material never used in containers intended for food preparation or storage.

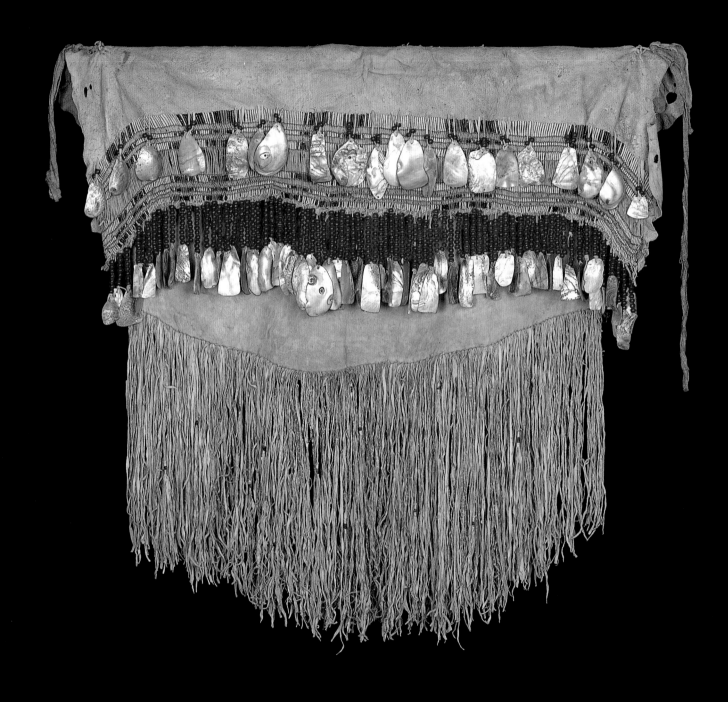

WOMAN'S DANCE SKIRT

Hupa. Klamath River, Northern California. c. 1850. Hide, brown alder, yellow willow, black maidenhair fern, abalone shell, glass beads. 34 × 35". T137. A. W. Erikson, Arcata, California in 1900; Larry Wendt, Santa Fe

For ceremonial occasions Hupa, Karok, and Yurok women wore special skirts that covered the buttocks and hips and lay over a narrow apronlike panel. The many shell pendants clicked to the rhythm of dancing and gave flashes of iridescence.

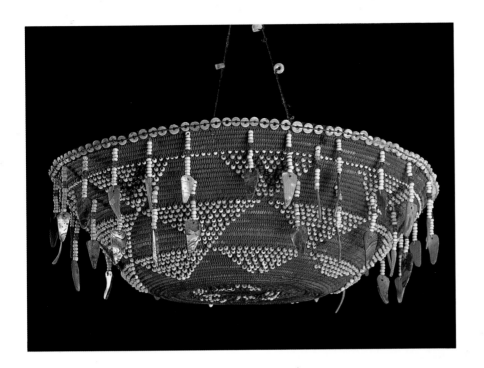

*Pomo. North-Central California coast. c. 1850.
7 h. × 11" diam. Willow rod, sedge root, glass
beads, abalone shells, clam shell disc beads,
cotton twine. T139. Sotheby's, #6297, June 12,
1992, lot 79*

The Pomoan people were among the
most skillful basketmakers in North
America. They made beautiful coiled
bowls and twined very fine "burden"
baskets for carrying and processing food.
Some of their most attractive baskets
were coiled and covered with brilliant
feathers or colored trade beads. They
were presented to friends and important
personages, or burned in funeral rites.

FEATHERED BASKET

*Pomo—probably Upper Lake Pomo. Upper Lake
County, California. c. 1910. 2 h. × 11½" diam.
Wooden rod, sedge root, feathers, clam shell beads,
abalone shell. T140. Jack D. Antle, Durango, Colorado*

The glowing mosaic of brilliant feathers gave
the name "jewel" basket to this particular form.
Popular from at least the 1850s, jewel baskets
were used by Central Pomoans as gifts to friends
or as presentations to honored persons. The
feathers were gathered from many birds, the red
crests of acorn woodpeckers, the topknots of
quail, and the green neck and head feathers of
mallard ducks.

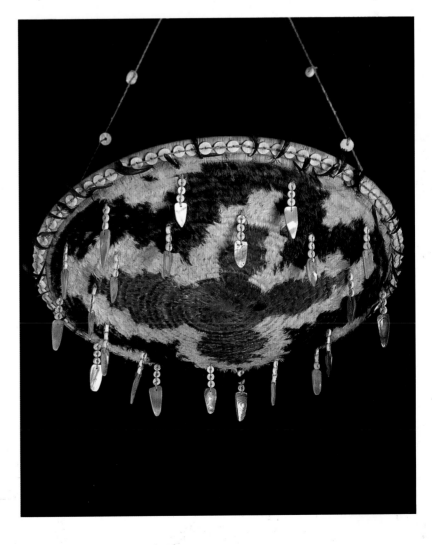

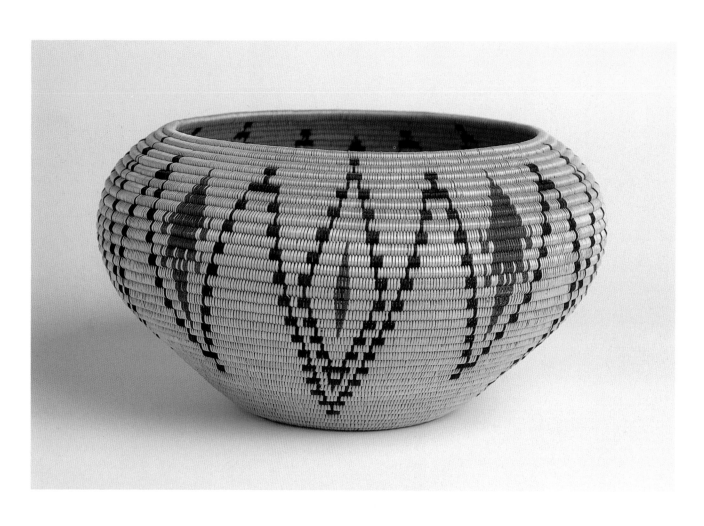

DEGIKUP

Washoe. Woven by Tootsie Dick Sam (d. 1928). Antelope Valley, California. c. 1919. 5½ h. × 10½″ diam. Redbud and bracken fern. T142. Natalie Fay Linn, Portland, Oregon

In the early twentieth century, Washoe basketry attracted national attention through the efforts of Abram Cohn, a Carson City merchant, and his wife Amy, who encouraged the work of Luisa Keyser, better known as Datsolalee (1850–1925). The degikup is a finely stitched, spheroid form with two-color decorations created by Keyser as a salable work of art. Tootsie Dick Sam was inspired by Keyser's example and became Cohn's second major protégée.

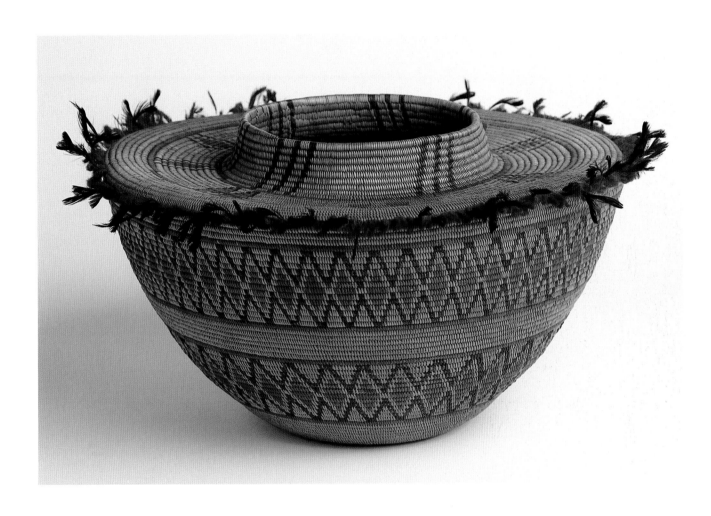

BOTTLENECK JAR

*Panamint. Death Valley region, California. c. 1895. 6¾ h. × 13½"
diam. Deer grass, willow or sumac, redbud, bracken fern root, woolen
yarn, quail feathers. T144. Claire Zeisler Collection, Chicago;
Morning Star Gallery, Santa Fe*

These distinctive jars are called bottle-necks, seed jars, or
treasure baskets, and were made by several tribes. This one is
shaped like Yokut bottle-necks, but is made of different mate-
rials. It is sewn with willow splints instead of sedge root and
the rattlesnake diamond bands are done with red yucca root
and black devil's claw. Rattlesnakes played a role in Panamint
mythology and the decorative bands imitating rattle- snake
markings may have a symbolic meaning.

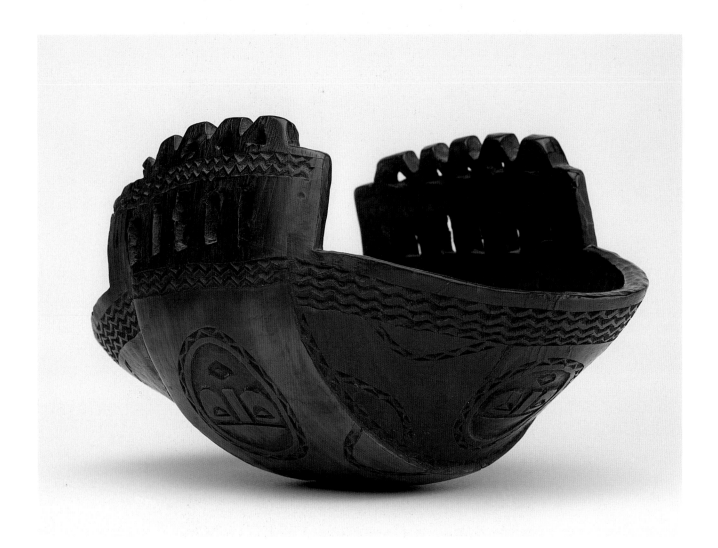

BOWL

Wishxam/Wasco. Lower Columbia River. 1800–50. Bighorn sheep horn. 5 h. × 6½ l. × 8½" w. T148. Morning Star Gallery, Santa Fe

The humanlike faces adorning this bowl may represent guardian spirits of Wishxam or Wasco life. Such bowls were created for use in the ritual feasts that followed the year's first gathering of roots preceding the annual harvest.

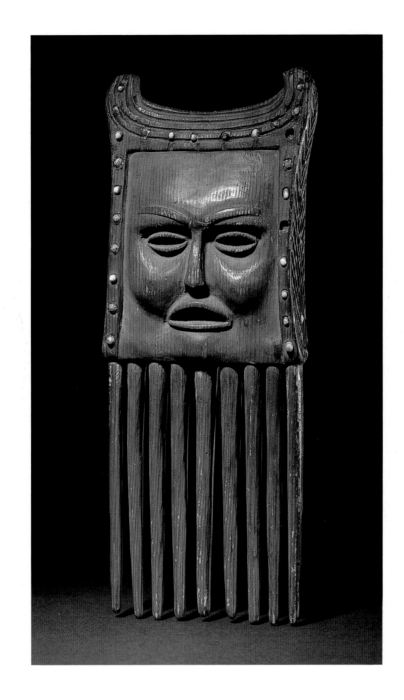

COMB

Nuu-chah-nulth (Nootkan). West Coast of Vancouver Island. 1750–1820.
Spruce, teeth or shell. 9½ h. × 4⅞ w. × 1⅝" depth. T156. George
Terasaki Collection, New York

The subtle modeling and expressive naturalism of the face
carving establishes this comb as a work of great artistry. A very
similar comb, collected by the English explorer Capt. James
Cook in 1778, is now in the Banks Collection, British Museum.

PAIR OF LIGHTNING SERPENT MASKS

Nuu-chah-nulth (Nootkan). Possibly Tla'oquiaht, Clayoquot Sound, Vancouver Island. 1860–80. Yellow cedar, spruce, fir, paint, red cedar bark, tin can, nails, cotton fabric, string. 8⅝ h. × 24½ l. × 7″ w. (female—left). 9½ h. × 26 l. × 6½″ w. (male—right). T159 a, b. John and Anne Van der Houwen, Yakima, Washington; Shaw Gallery, Aspen, Colorado

The Lightning serpent is a creature unique to the art and dance of the Nuu-chah-nulth and Makah. Masks representing the serpent are worn on top of the head and are traditionally made in matched pairs. The interiors of these masks contain simple mechanisms to scatter eagle down into the air as the dancers performed.

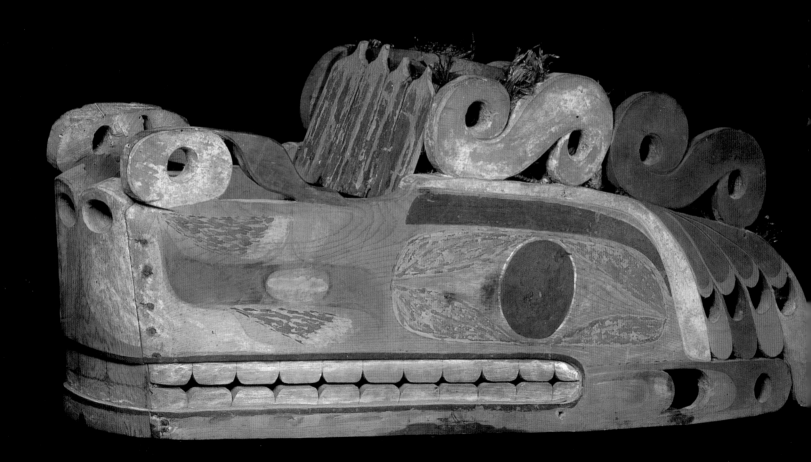

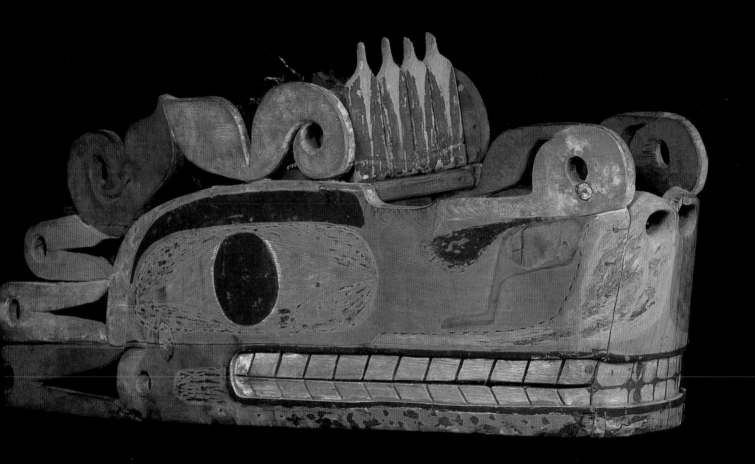

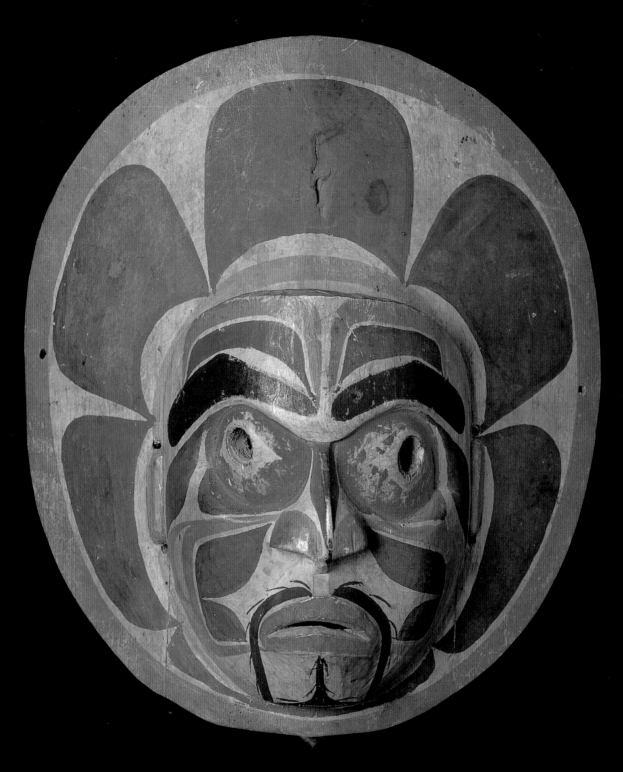

MOON MASK

Heiltsuk (Bella Bella). British Columbia Mainland/Milbanke Sound area. 1880–1900. Alder, paint. 13¾ h. × 12¼ w. × 6″ depth. T164. Harry B. Hawthorne, Vancouver, British Columbia; George Terasaki Collection, New York

Painted coronas around masks are associated with both moon and sun imagery. The brilliant blue lobes and crescent shape of this corona suggest a moon representation.

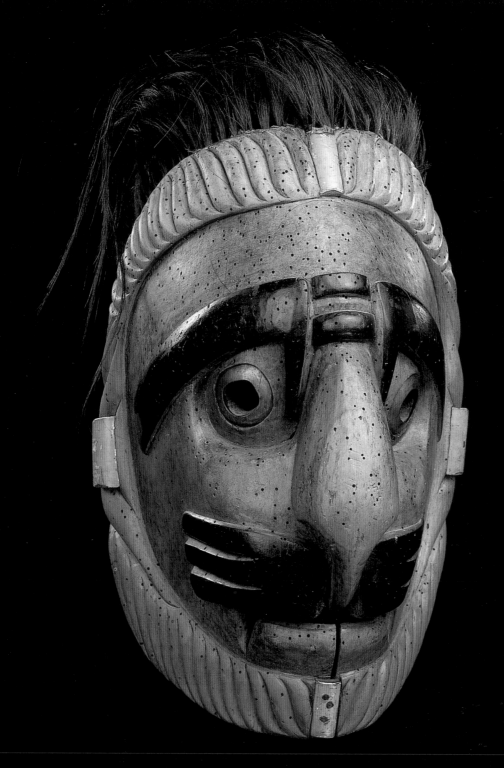

NUL'AMAL (NOOHLMAHL) MASK

Kwakwaka'wakw (Kwakiutl), Gwats'inuxw. Northwest Vancouver Island. 1830–50. Alder, paint, human hair, copper, sealskin strap, sinew thread, enameled wood pieces (added at a later date). 13⅛ h. × 9 w. × 8¼" depth. T161. Miss Cowie, England or Scotland, presented to unknown collection in 1863; Earls of Derby, England; Mathias Komor, New York; Sotheby's, #4708Y, October 23, 1981, lot 385; Private Collection, Canada; Judith Small Nash, New York

The Nul'amal is known in English as the Fool Dancer, a strange character from ancient Kwakwaka'wakw tradition who is sensitive to his oversized nose and functions as an enforcer of proper protocol on ceremonial occasions. This mask is one of a small group that adapts the imagery of lion heads that were seen by Natives on the cathead timbers and other parts of European and American sailing ships.

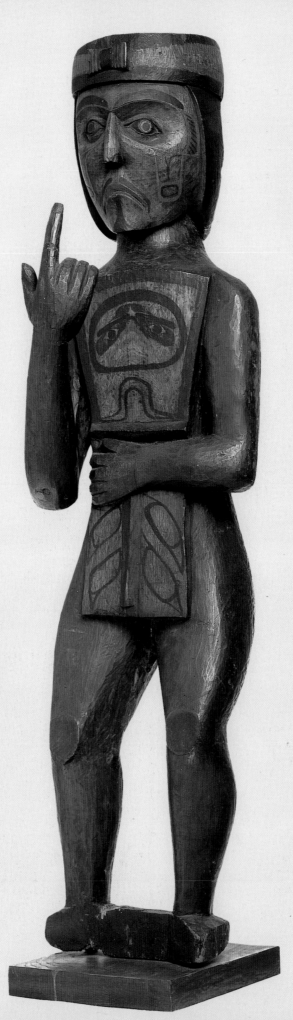

POTLATCH FIGURE, MAN HOLDING A COPPER

Kwakwaka'wakw (Kwakiutl). Northwest Vancouver Island. 1880–95. Red cedar, paint, nails. 50 h. x 13½ w. x 15″ depth. T162. Wolfgang Paalen, Mexico City, Mexico, probably collected in 1939; Ralph C. Altman, Los Angeles; Taylor Museum, Colorado Springs, Colorado in 1951

Some of the finest treasures of nineteenth-century Kwakwaka'wakw art are wooden statuettes displayed at Potlatch festivities. This figure represents a chief wearing a traditional cedar bark headring and holding a hammered copper plate denoting chiefly status. The position of his right hand and raised index finger probably represents the high status of his family, but more precise information remains unknown.

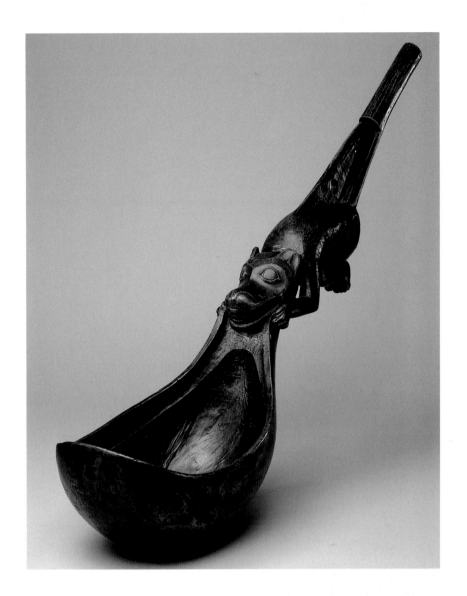

FEAST LADLE

Coast Tsimshian. Northern British Columbia Mainland and Islands. c. 1840. Alder, paint. 35¼ l. × 9 w. × 9" depth. T167. Collected by George Hills, First Bishop of British Columbia; St. Augustine's Missionary College, Kent, England, in 1865; James Hooper, Sussex, England, in 1946; British Rail Pension Trust; Christie's, November 9, 1976, lot 164; James Economos, Santa Fe; Stefan Edlis, Chicago, in 1980

Among many Northwest peoples a family's status was reinforced by the hosting of large gatherings or potlatches that included feasting. The scale of this ladle suggests munificent hospitality; the handle affirms the family's hereditary crests and emblems in the shape of a bear or wolf head with a human body and the back fin of a whale.

BOWL

Coast Tsimshian or Nishga. Southeast Alaska. 1820–50. Alder, red turban snail opercula. 7½ h. × 13½ l. × 8¼" w. T170. William Randolph Hearst Estate, California; Channing Peake Collection, in 1951; James M. Jeter, Summerland, California

Richness of color, expressiveness, and craftsmanship permeate this image of a hooked-beak bird with its animated wings and tail. The representation may be Naas-Shaki-Yeił, the Raven-at-the-Head-of-the-Nass who, in Northwest Coast beliefs, owned the boxes in which daylight was kept.

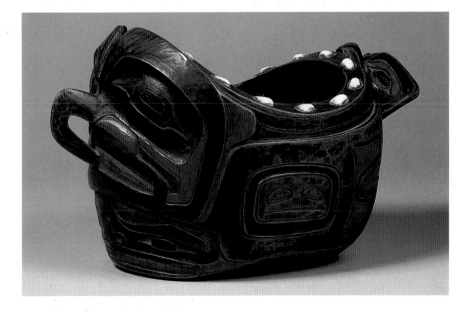

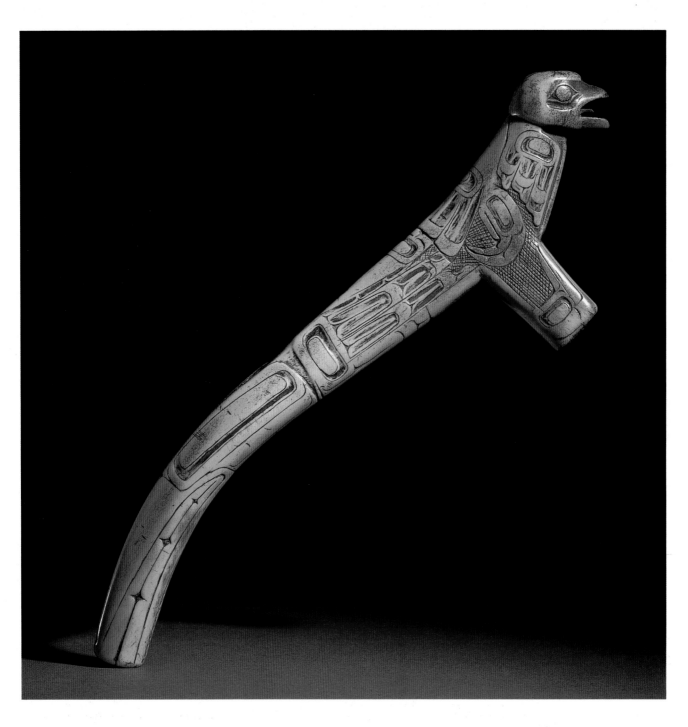

CLUB

Coast Tsimshian. Northern British Columbia Mainland and Islands. 1800–30. Elk antler. 16½ l.
× 5 w. × 1″ depth. T171. Admiral the Hon. George Fowler Hastings, collected in 1867; Mrs.
Geoffrey Anderton (granddaughter of Hastings), England; Sotheby's, London, November 28,
1966, lot 62c; Merton Simpson, New York; John Friede Collection, Brooklyn, New York; Private
Collection, Canada; Judith Small Nash, New York

Formidable war clubs from branches of bull elk antlers were made in the northern
British Columbia area from very early times. The middle branch originally held a
stone or metal point. Two bird images, one greatly elongated and with a beak full of
teeth, are integrated into the curving shaft.

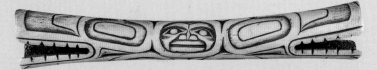

SOUL CATCHER

*Tsimshian. Northern British Columbia Mainland.
1840–70. Bone (Grizzly bear humerus?). 6⅗ l.
× ⅞″ h. T172. Edith Walker, Vancouver, British
Columbia, collected prior to 1908; descended in
family; Christie's, London, July 4, 1989, lot 31*

Soul Catcher is the English term for bone
tubes used by shamans in healing procedures.
Shamanic medicine focuses on spiritual
causes rather than on symptoms and these
tubes might be used to capture souls influ-
enced by witchcraft or out of balance with
the physical body. The humanoid face in the
center could symbolize the captured soul,
protected by the fierce creatures at either end.

RATTLE

*Coast Tsimshian. British Columbia Mainland and
Islands. 1840–60. Maple, paint, leather, sinew.
4 h. × 4 w. × 12⅞″ l. T174. Julius Carlebach,
New York in 1965; George Terasaki Collection,
New York; Stefan Edlis, Chicago*

Raven rattles have been made for many
generations along the length of the Northwest
Coast. By the early nineteenth century the
form achieved an extraordinary artistic
refinement. The image of the raven-human-
raven originates with native creation beliefs.

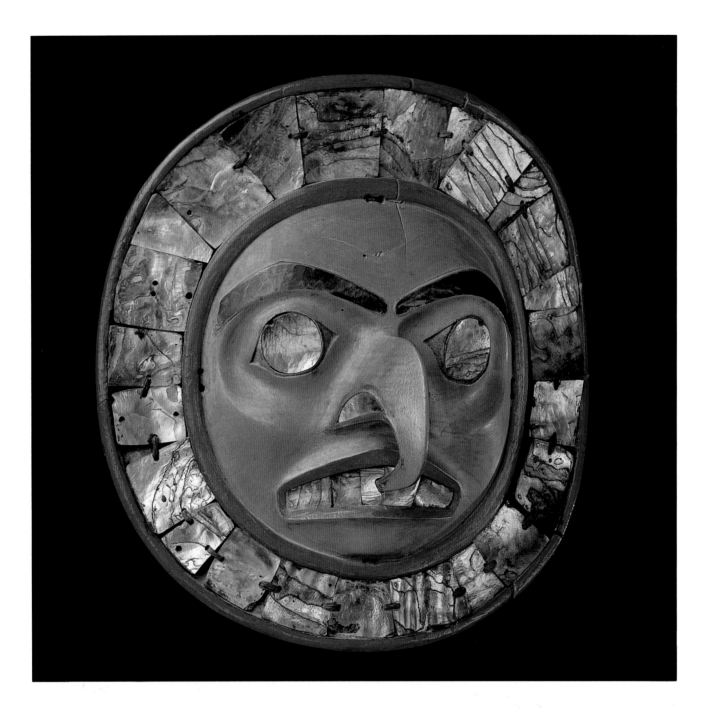

FRONTLET

*Tsimshian (Coast?). Northern British Columbia Mainland (and Islands?). 1840–70. Maple,
paint, abalone, Native copper repair on back, twine and string. 8¾ h. × 8 w. × 3½" depth.
T177. Alert Bay Kwakwaka`wakw via Native trade; Henry George, Port Hardy, British Columbia;
Norman Feder, Sydney, British Columbia; Morton Sosland, Kansas City; Sotheby's, #4472Y,
November 15, 1980, lot 344; Stefan Edlis, Chicago*

Few frontlets attain the mastery of design and execution evidenced here. Interpretation of
the imagery may vary. The recurved beak image may refer to a hawk or thunderbird and
a particular family crest. The corona of reflective abalone may refer to the sun, suggesting
that the central creature is Naas-Shaki-Yeił, Raven-at-the-Head-of-the-Nass, the embod-
iment of the creator, the owner of daylight, and grandfather of Raven, the world's transformer.

DISH

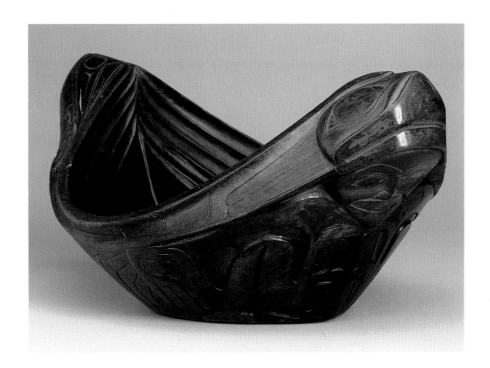

Haida. Queen Charlotte Islands or Southeast Alaska. 1820–50. Alder. 7¼ h. × 15½ l. × 10½″ w. T179. Alton L. Dickerman, collected in Sitka, Alaska, c. 1883; Miss Foster B. Dickerman, Colorado Springs, Colorado; Mrs. Alice Bemis Taylor, Colorado Springs, Colorado, in 1928; Taylor Museum, Colorado Springs, Colorado, in 1954

The bold sweeping curve of the dish maintains a traditional form while capturing the natural movement of a seal. The wood is saturated by long use with seal or eulachon oil, a valuable and important ingredient in the Northwest Coast diet.

DISH

Haida. Queen Charlotte Islands, British Columbia. 1840–60. Dall sheep horn. 4¾ h. × 8¾ l. × 6½″ w. T181. Alton L. Dickerman collected in Sitka, Alaska, c. 1883; Miss Foster B. Dickerman, Colorado Springs, Colorado; Mrs. Alice Bemis Taylor in 1928, Colorado Springs, Colorado; Taylor Museum, Colorado Springs, Colorado in 1954

Most horn dishes are symmetrical, but a few Haida artists developed images with distinct front-and-rear orientation in the design. A small seabird, possibly a merganser, is depicted here.

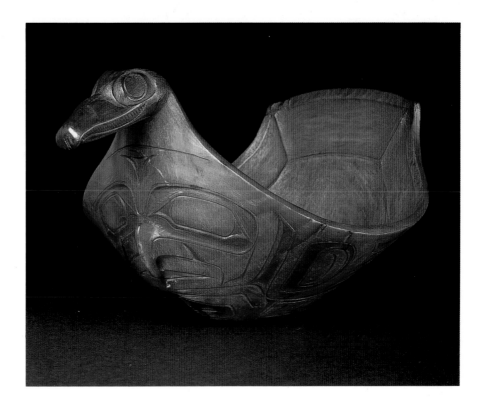

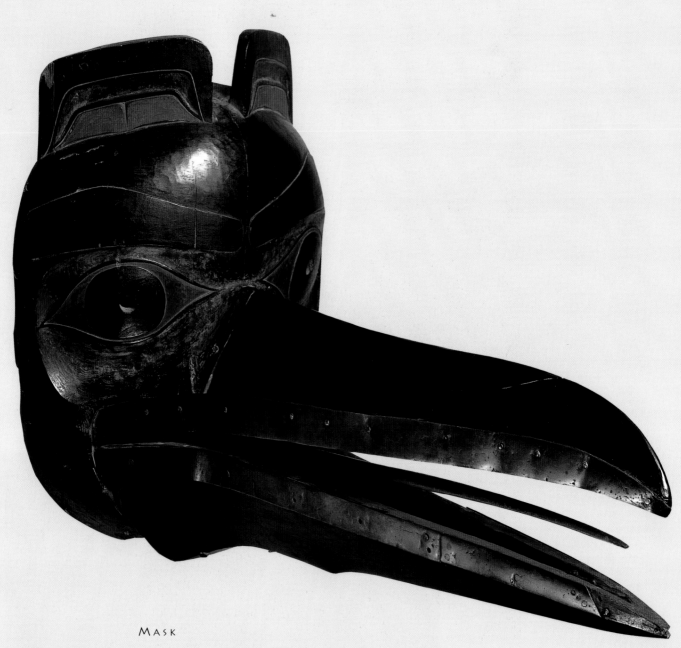

MASK

Haida (southern Tlingit?). Queen Charlotte Islands or Southeastern Alaska. 1810–50. Yellow cedar, copper, paint, skin straps. 13 h. × 18¼ l. × 9″ w. T185. Private Collection, Stockbridge, Massachusetts; William Channing, Santa Fe; George Terasaki Collection, New York

The raven is not only important to the creation beliefs of the Northwest Coast people, but is also the symbol of one of the two opposite halves, called phratries or moieties, dividing Haida and Tlingit societies. Used by a talented dancer or performer during firelit ceremonies, the mask must have created a dramatic effect with its articulated beak and tongue and polished dark surface.

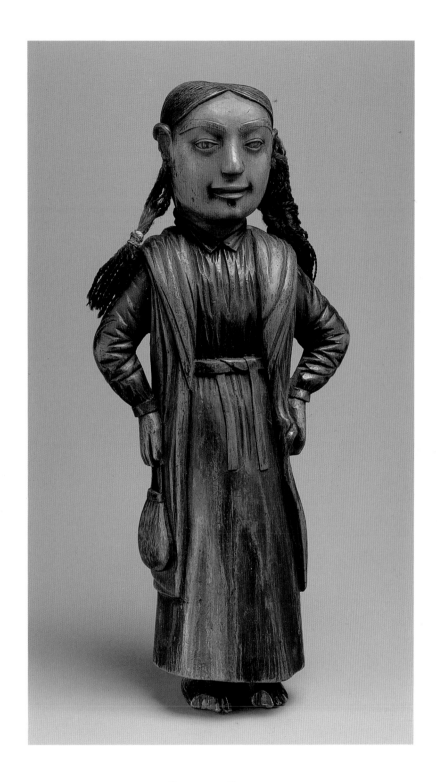

FEMALE FIGURE

Haida. Queen Charlotte Islands, British Columbia. c. 1830. Hardwood (possibly crab apple), wool, paint. 11 h. × 5 w. × 2⅞" depth. T186. George Terasaki Collection, New York

This is a representation of an acculturated Haida woman of high birth with multiple ear pendants and a small labret in the lower lip. Statuettes of comparable size were made for general sale, but seldom do they attain the sculptural sophistication or expressive quality seen in this example.

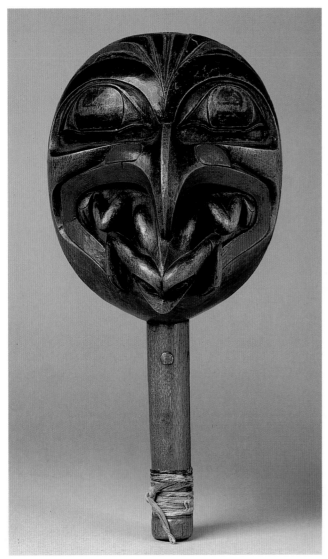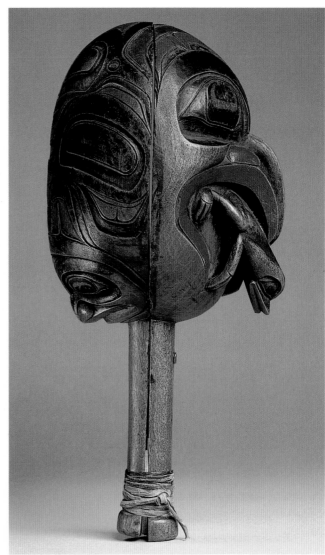

RATTLE

*Haida Queen Charlotte Islands or Southeast Alaska. 1800–30. Alder or birch, paint, cotton
cloth, copper nail, pebbles. 10¼ h. × 5 w. × 4¾″ depth. T191. Lt. (later Admiral) Gordon,
England, collected in vicinity of Queen Charlotte Islands, before 1854; James Hooper Collection,
Surrey, England, in 1950; British Railway Fund; Christie's, London, November 9, 1976, lot 177;
James Economos, Denver; Stefan Edlis, Chicago*

Globular rattles are associated with the power of shamanism along the Northwest
Coast, possibly because of their similarity to the human cranium as a symbol of the
spirit world. Haida carvers raised the tradition of carving this shape to a high art.

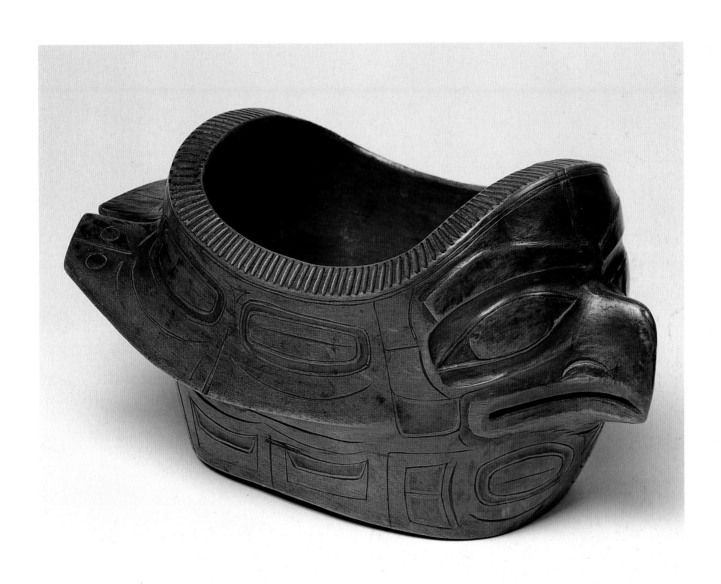

BOWL

Tlingit. Southeast Alaska. 1820–60. Alder, paint. 5⅛ h. × 5¾ w. × 9¼″ l. T198. George Terasaki Collection, New York

The projecting masklike face of a bird is well adapted to the deep, bulging dish form. The image may represent a raven, but there are many birds in the family crests of the Tlingit and without substantial family documentation it is difficult to identify the species depicted here.

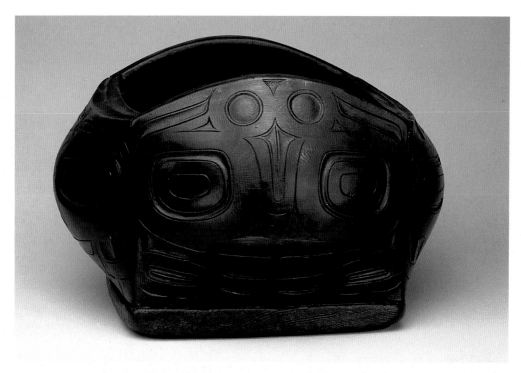

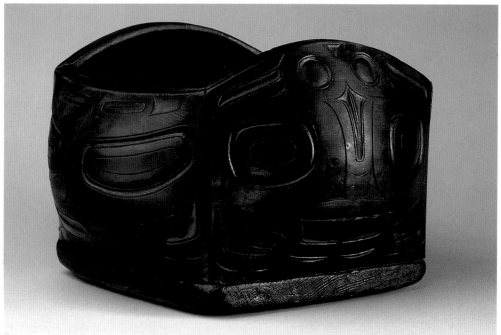

BENT-CORNER DISH

*Tlingit/possibly Tsimshian. Southeast Alaska. 1750–1800. Yew, red cedar, fiber cordage. 13 l. ×
9″ w. T199. Alton L. Dickerman, collected in Sitka, Alaska, c. 1883; Miss Foster B. Dickerman,
Colorado Springs, Colorado; Mrs. Alice Bemis Taylor, Colorado Springs, Colorado, in 1928;
Taylor Museum, Colorado Springs, in 1954*

The bulging profile of the formline-carved sides creates an artistic symbol for the
owner's hospitality and bounty at a feast or celebration. The dish evidently has been
well used: the wood is thoroughly saturated with oil.

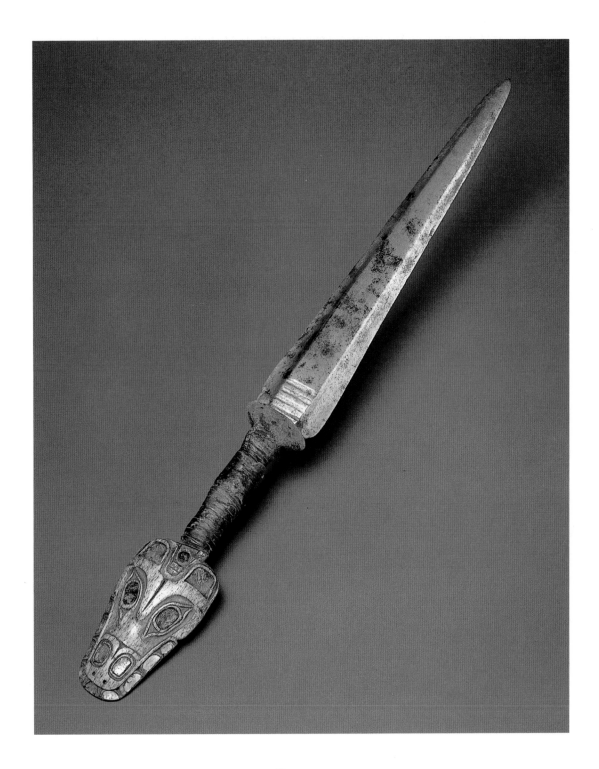

DAGGER

Tlingit. Southeast Alaska. 1790–1810. Whale bone, steel, abalone, copper rivet, leather, cotton, pitch, pigment. 20½ × 2½". T203. George Terasaki Collection, New York

Fighting daggers were important weapons for Northwest Coast warriors, and the scale of this dagger must have made it seem formidable to an opponent. The whalebone pommel, carved and inlaid in the shape of a wolf's head, balances the predatory look of the pointed blade.

MASK

Tlingit. Southeast Alaska. 1820–50. Alder, paint, leather. Inscription on forehead: "(In)dian mask/made (by) Tli(ngit)/J.G. Swan." 9½ h. × 7⅛ w. × 4" depth. T212. Collected by James G. Swan, Port Townsend, Washington Territory, c. 1880(?); George Terasaki Collection, New York

This image appears to represent a shaman's eagle spirit, though only its original owner would have known what was intended by the sculpture. The beautiful turquoiselike blue of many Tlingit masks is derived from natural minerals found along the coast.

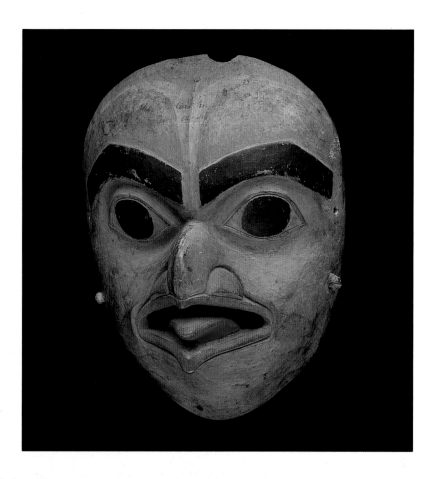

FOREHEAD MASK

Tlingit. Southeast Alaska. 1820–40. Alder, paint, abalone, sea lion whiskers. 5½ h. × 6¾ w × 9½" l. T211. George Terasaki Collection, New York

Small forehead masks were often worn at potlatches—large celebrations that included feasting, dancing, reciting family histories and distributing gifts to guests. The image most likely represents a clan crest, either a wolf or bear. The sea lion whiskers held eagle down and as guests arrived, the motions of the wearer would scatter the down as a sign of peace and good will.

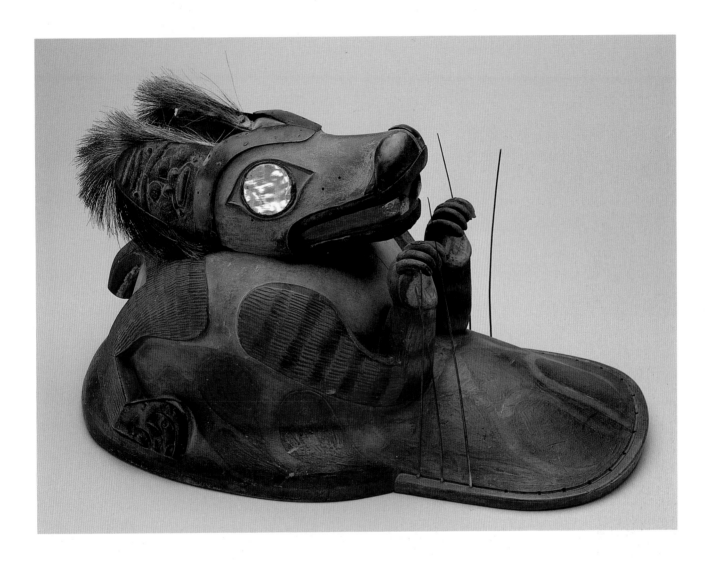

H AT

*Tlingit. Southeast Alaska, Yakutat? 1830–60. Alder, copper, abalone, sea lion whiskers, porcupine
· skin, paint, leather straps. 8½ h. × 16 l. × 10″ w. T209. J. J. Klejman, New York; J. W. Turner,
Tuscaloosa, Alabama; Sotheby's, #4366, April 26, 1980, lot 420; Morton D. May, St. Louis;
Stefan Edlis, Chicago*

Most Tlingit clan-emblem hats made of wood derive from the form of woven spruce
root hats. This example imitates the duck-billed or visored hats of the Pacific Eskimo
from Norton Sound and represents a convergence of two cultures. The image is that
of a bear, skillfully carved and painted, and richly decorated with abalone, copper bas-
relief designs, porcupine skin, and sea lion whiskers.

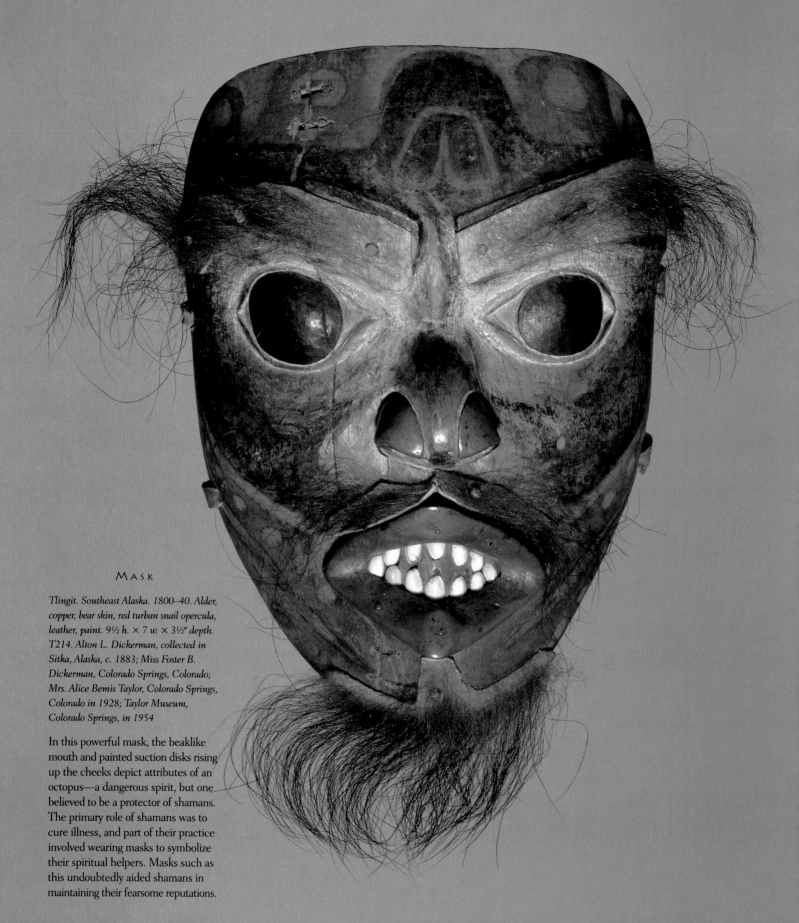

MASK

Tlingit. Southeast Alaska. 1800–40. Alder, copper, bear skin, red turban snail opercula, leather, paint. 9½ h. × 7 w. × 3½" depth. T214. Alton L. Dickerman, collected in Sitka, Alaska, c. 1883; Miss Foster B. Dickerman, Colorado Springs, Colorado; Mrs. Alice Bemis Taylor, Colorado Springs, Colorado in 1928; Taylor Museum, Colorado Springs, in 1954

In this powerful mask, the beaklike mouth and painted suction disks rising up the cheeks depict attributes of an octopus—a dangerous spirit, but one believed to be a protector of shamans. The primary role of shamans was to cure illness, and part of their practice involved wearing masks to symbolize their spiritual helpers. Masks such as this undoubtedly aided shamans in maintaining their fearsome reputations.

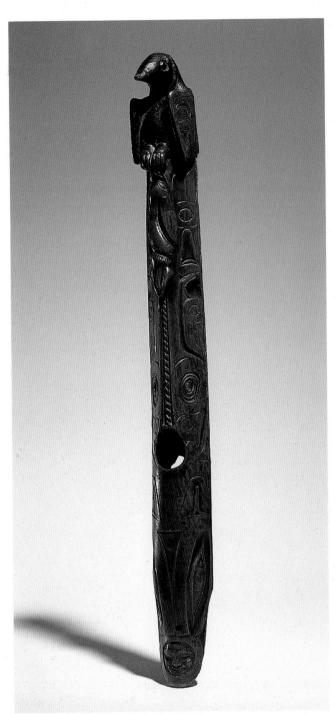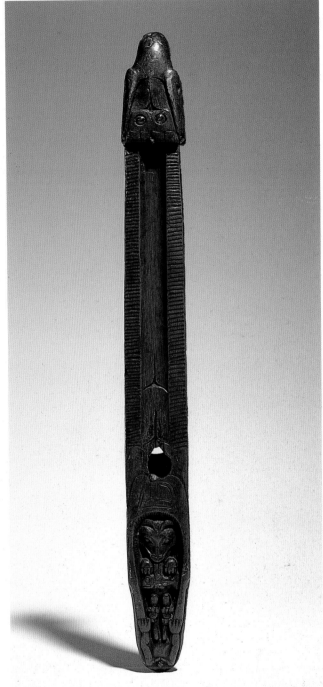

ATLATL

Tlingit. Southeast Alaska. 1750–1800. Yew, glass beads, iron pin. 15 l. × 1½ w. × 1" depth.
T218. Private Collection, England; Christie's, London, December 8, 1992, lot 153

The atlatl, a Nahuatl word for a throwing stick, was held in the hand and extended
the forearm to propel a spear with greater force through increased leverage. Only a
few Tlingit atlatls exist: they are highly decorated, date from the eighteenth century,
and are not functional for spear throwing. It is thought that they may be shamanic and
were used symbolically for hunting in the spirit world.

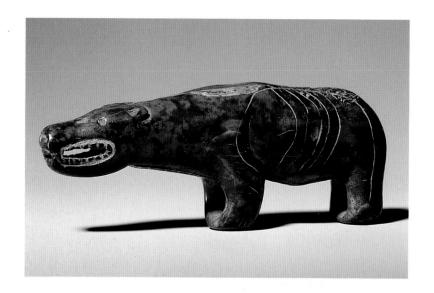

BEAR CARVING

Ipiutak. Seward Peninsula, Alaska. A.D. 100–600. 1¾ h. × 4½ l. × 1" w. Walrus ivory. T225. Excavated from the Point Spencer area, Seward Peninsula, Alaska, August 10, 1991; Jeffrey R. Myers, New York; Ron Nasser, New York

The Ipiutak tradition was a mainland Alaskan carving style and marked a milestone in Eskimo perception, because it uniquely concentrated both on depicting the realistic features of animals and capturing their spirit.

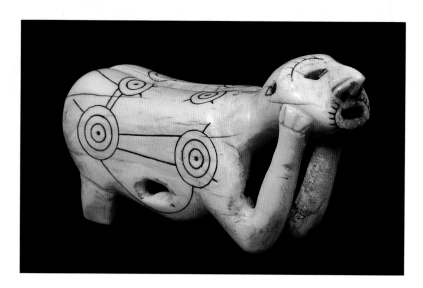

TOGGLE

Southwestern Eskimo. Bristol Bay area, Alaska. c. 1850. 2½ h. × 4½ l. × 1½" w. Ivory. T236. Shaw Gallery, Aspen, Colorado

Although carvings of this type have been called Pacific Eskimo, these works most likely originate among the Southwestern Eskimo: this example was collected at Bristol Bay, Alaska. The form is a human figure leaning on its elbows. The engraved decorations and openings indicate its use as a toggle to fasten a garment.

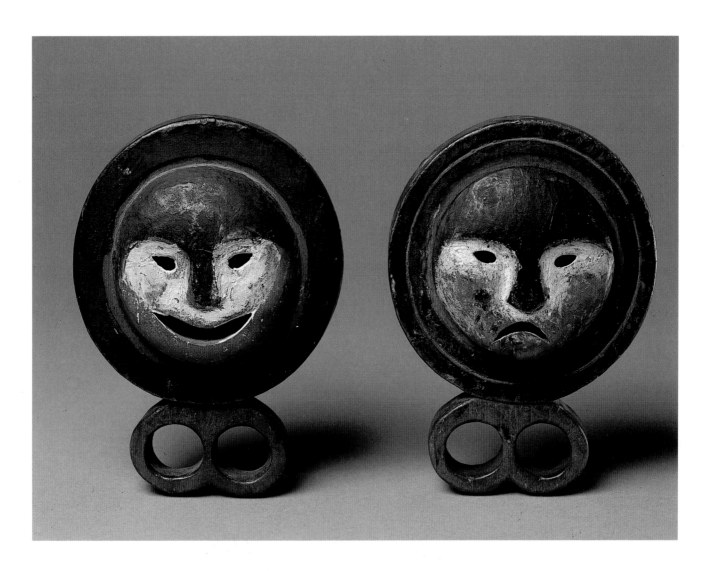

FINGER MASKS, PAIR

Eskimo. Alaska. c. 1870. 4¾ h. × 3½ w. × 1½″ depth. Wood, pigments. T229. Collected by a Jesuit missionary in Alaska in 1870 or 1886; Roman Catholic mission in Wheeling, West Virginia; Pacific Northwest Indian Center, Spokane, Washington; Robert L. Stolper, Munich and New York; Andre Nasser, New York

Finger masks are worn by women when dancing in religious or folk ceremonies. Feathers and strips of fur were often added to the rims to animate the images and extend the movements of the dancer. As on the faces of larger masks, males are represented by an upturned mouth and females by a downturned mouth.

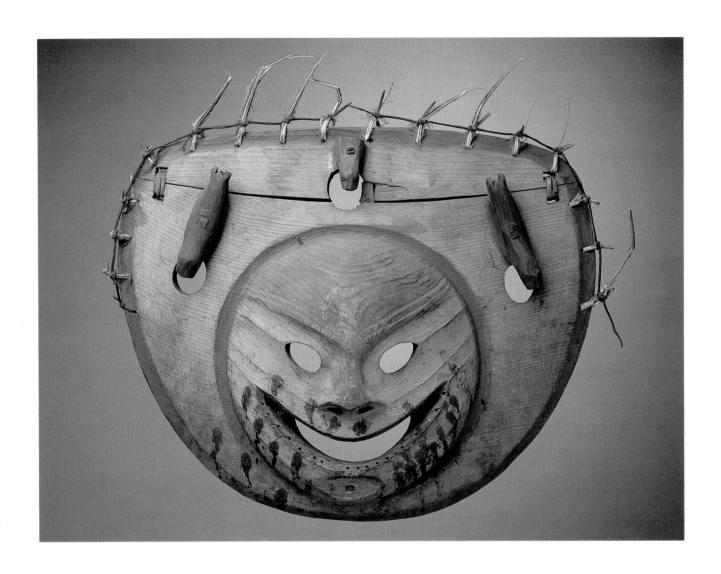

MASK

Eskimo. Alaska. c. 1850. 16¼ h. × 20½ w. × 4¾″ depth. Wood, feathers, hide, root, pigments. T231. Collected by a Jesuit missionary in Alaska in 1870 or 1886; Roman Catholic mission, Wheeling, West Virginia; Pacific Northwest Indian Center, Spokane, Washington; Robert L. Stolper, Munich and New York; James Economos, Santa Fe; Andre Nasser, New York

This mask was most likely used in a ceremony involving hunting magic. A probable intention is to show respect for the soul, or inua, of the seal in hopes to ensure a successful hunt and a replenishing of seals for the future.

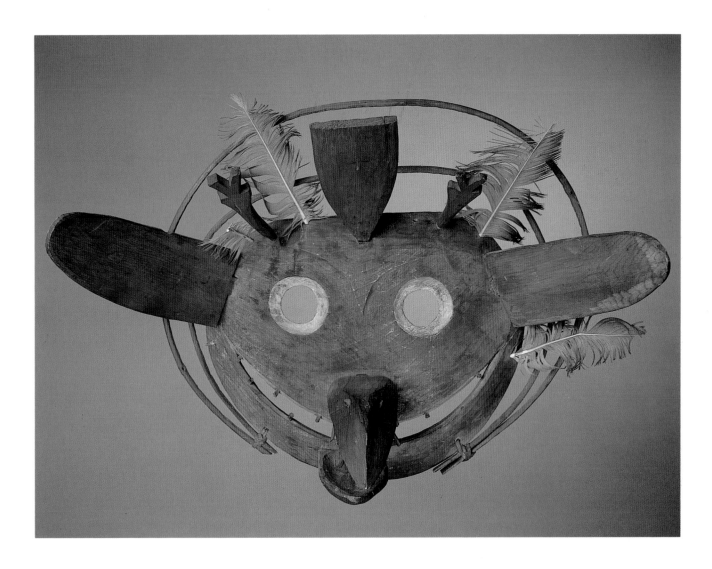

MASK

Napaskiagmut Eskimo. Kuskokwim River, Alaska. c. 1875. 15½ h.
× 25¼ w. × 8″ depth. Wood, feathers, pigments. T232. A. Twitchell,
Bethel, Alaska; Heye Foundation/Museum of the American Indian,
New York in 1919; Julius Carlebach, New York in 1944; Merton
Simpson, New York; Andre Nasser, New York

An important figure in Eskimo creation beliefs, raven was also
connected as a friend and guardian to whales and whalers. An
image such as this would have been used in ceremonies to
insure a successful hunt.

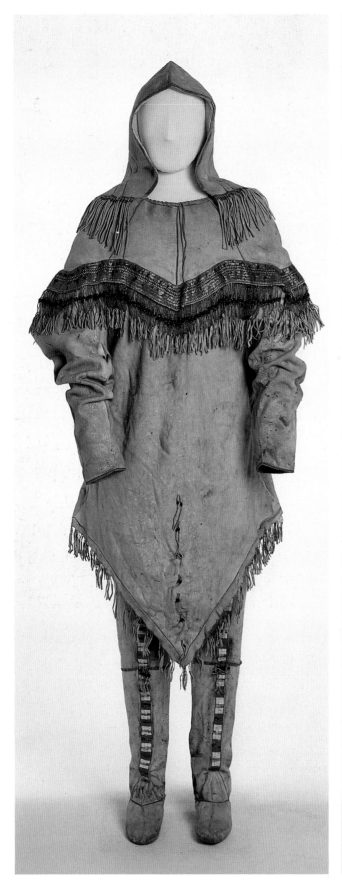 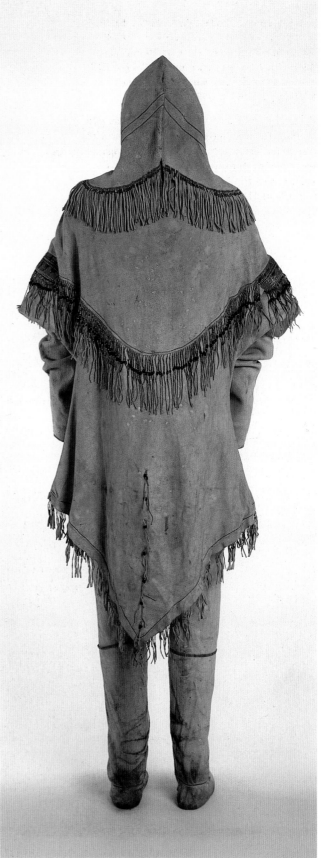

OUTFIT

Western Athapaskan, Kutchin type. Alaska. c. 1882. Hood 19 × 11"; tunic 46 × 30"; moccasin trousers 41 × 18". Hide, quillwork, seed pods. T237. Capt. Henry Phillips Dawson, Royal Society, collected between 1882 and 1883 at Fort Rae, Canada; descended in family; Sotheby's, #6427, May 25, 1993, lot 199

The long, pointed tunic and moccasin trousers with extensive quillwork and fringe are a type of aboriginal clothing that dates back at least to the early eighteenth century. The extraordinary condition of this outfit suggests that it was hardly used, and may have been acquired by Captain Dawson as an example of traditional summer clothing.

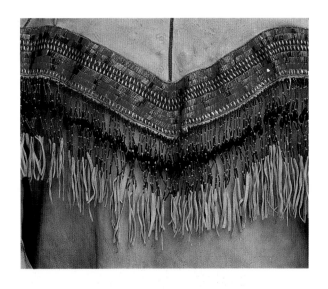

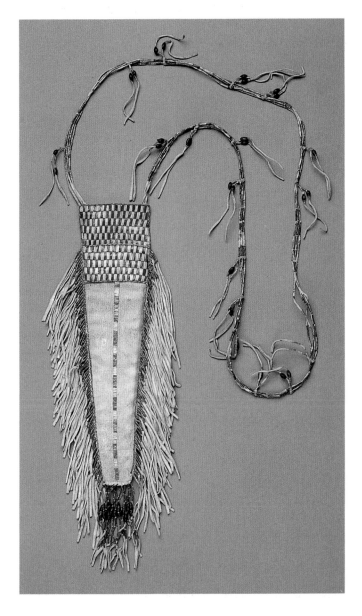

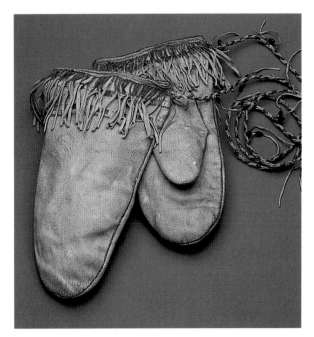

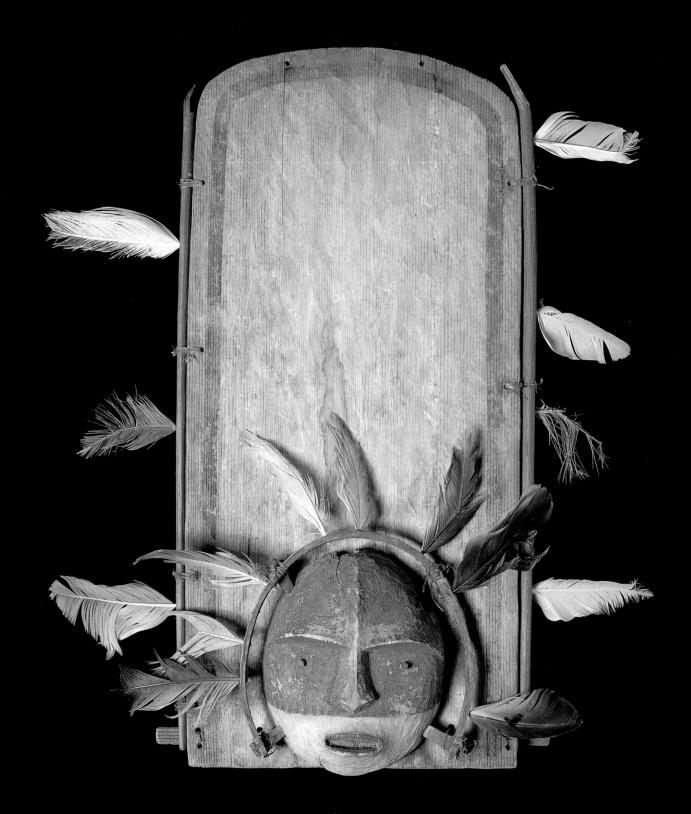

MASK

Koniag Eskimo. Kodiak Island, Alaska. c. 1850. 14½ h. × 7¼ w. × 2¼″ d. Cedar wood, feathers, sinew threads, pigments. T234. George Terasaki Collection, New York; Chester Dentan, Santa Fe; Morning Star Gallery, Santa Fe

Small masks placed on a long plank back with an encircling hoop are said to represent "Happy Fellow," and are part of a set used in a six-act mystery play. Held in men's halls, called kashims, such long plays would take place during the winter months.

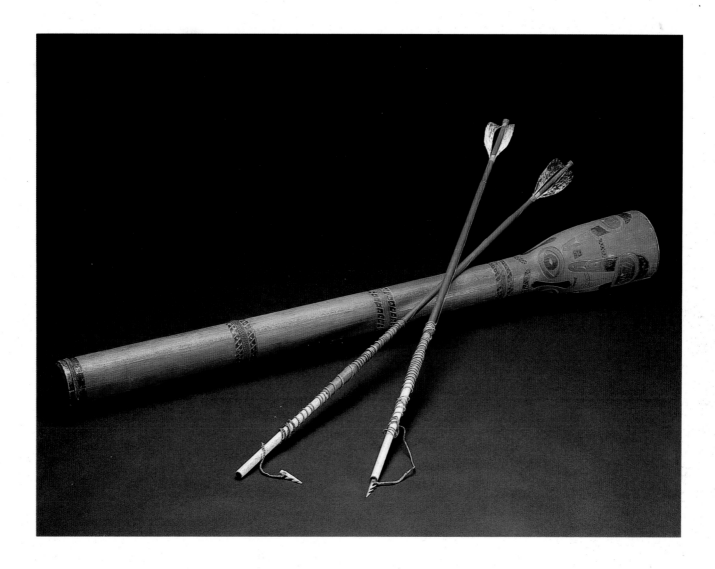

QUIVER AND ARROWS

Chugach. Prince William Sound, Alaska. 1825–50. Quiver 36½ l. × 4″ diam. Wood, sinew, pigments, bone, brass, feathers. T238. Alton L. Dickerman, collected in Sitka, Alaska, c. 1883; Miss Foster B. Dickerman, Colorado Springs, Colorado; Mrs. Alice Bemis Taylor, Colorado Springs, Colorado, in 1928; Taylor Museum, Colorado Springs, Colorado, in 1954

The simplified formline decoration on the quiver recalls the artistic vocabulary of the Tlingit, close neighbors of the Chugash to the south. The harpoon arrows with detachable heads are admirable for both form and function. They are designed to hunt sea otters, once plentiful in Prince William Sound.

BIBLIOGRAPHY

Brasser, Ted. J. *"Bo'jou Neejee!": Profiles of Canadian Indian Art*. Ottawa: National Museum of Man, 1976.

Coe, Ralph T. *Sacred Circles: Two Thousand Years of North American Indian Art*. London: Arts Council of Great Britain, 1977.

Ewers, John C. *Plains Indian Sculpture: A Traditional Art from America's Heartland*. Washington, D. C.: Smithsonian Institution Press, 1986.

Fane, Diana, Ira Jacknis, and Lise M. Breen. *Objects of Myth and Memory: American Indian Art at the Brooklyn Museum*. Brooklyn: The Brooklyn Museum, 1991.

Feder, Norman. *Two Hundred Years of North American Indian Art*. New York: Whitney Museum of American Art, 1971.

Frank, Larry and Francis H. Harlow. *Historic Pottery of the Pueblo Indians, 1600–1800*. Boston: New York Graphic Society, 1974.

Glenbow Museum. *The Spirit Sings: Artistic Traditions of Canada's First People, a Catalogue of the Exhibition*. Calgary: Glenbow–Alberta Institute, 1987.

Hail, Barbara A. *Hau, Kola!: The Plains Indian Collection of the Haffenreffer Museum of Anthropology*. Providence: Haffenreffer Museum of Anthropology, Brown University, Studies in Anthropology and Material Culture, vol. 3, 1980.

Holm, Bill. *The Box of Daylight: Northwest Coast Indian Art*. Exhibition catalogue. Seattle: Seattle Art Museum and University of Washington Press, 1983.

Jonaitis, Aldona, ed. *Chiefly Feasts: The Enduring Kwakiutl Potlatch*. New York: American Museum of Natural History, 1991.

Kent, Kate Peck. *Prehistoric Textiles of the Southwest*. School of American Research Southwest Indian Art Series. Santa Fe: School of American Research; Albuquerque: University of New Mexico Press, 1983.

Maurer, Evan M. *The Native American Heritage*. Chicago: The Art Institute of Chicago, 1973.

Maurer, Evan M. *Visions of the People: A Pictorial History of Plains Indian Life*. Minneapolis: Minneapolis Institute of the Arts, 1992.

Penney, David W. *Art of the American Indian Frontier: The Chandler–Pohrt Collection*. Detroit: Detroit Institute of Arts, 1992.

Penney, David W., ed. *Great Lakes Indian Art*. Detroit: Wayne State University Press, 1989.

Peterson, Jacqueline and Jennifer S. H. Brown, eds. "In Search of Métis Art." In *The New Peoples: Being and Becoming Métis in North America*, 1985.

Phillips, Ruth B. *Patterns of Power: The Jasper Grant Collection and Great Lakes Indian Art of the Early Nineteenth Century*. Kleinburg, Ontario: McMichael Canadian Collection, 1984.

Wardwell, Allen. *Objects of Bright Pride*. New York: American Museum of Natural History, 1978.

Whiteford, Andrew H. *Southwestern Indian Baskets: Their History and Their Makers*. Santa Fe: School of American Research Press, 1988.